"Carol Berry interweaves her own stories with Henri Nouwen's and with those of the artist who inspired them both, Vincent van Gogh. Her deep insights into struggle, solidarity with people, and the nature of creativity are powerful and universal. With careful research and thoughtful reflections, Berry clearly shows the reader the interconnections of their journeys and the threads of beauty they share. As an artist, Berry is able to share from her own sensitivity and insights into Vincent's art making. The printed artworks within allow the reader to reflect on the narrative. I loved this beautiful, deeply felt book."

John August Swanson, artist and printmaker

"Carol Berry's deep knowledge of Vincent van Gogh, facilitated early on by her friendship with Henri Nouwen, helps us better connect our own suffering and the suffering of others to a more compassionate way of life. Carol invites us to move into the realm of mystery and grace as she underscores the humility and humanity of both men whose ultimate concern was to live practically and lovingly using Jesus as their guide and model. Berry weaves together the lives of these two great Dutch spiritual masters and then offers wonder-filled personal experiences of compassion. For Carol, Henri and Vincent are two wounded healers of the world. They are true brothers able in their own unique but powerfully connected way to heal so many—even now. Berry's book is an inspiration."

Richard Rohr, Center for Action and Contemplation

"Henri Nouwen and Vincent van Gogh are two of my favorite people. Their word and art inspire me daily, pointing me back to our beloved God, the glories of creation, swirling night skies and wheat fields, and sisters and brothers of every walk. Carol Berry unpacks their lessons and, like Henri and Vincent, offers the most beautiful gift—a sense of hope. Just what we need."

John Dear, author of *The Questions of Jesus* and *The Nonviolent Life*

"From the moment I first discovered that Henri Nouwen taught a course at Yale Divinity School on the life and work of Vincent van Gogh, I searched for his class notes only to be disappointed to discover that they were never published—until now. Carol Berry has written the book I longed to find, weaving Nouwen's enduring wisdom with van Gogh's singular gift of using art to comfort and console. Nouwen and van Gogh—both wounded healers—invite us to a life of compassion, humility, and sacrificial love. With deep insight and sensitivity, Berry creates space for us to connect our stories with theirs and to discover what is worth seeing: the radiant beauty of hope within suffering and Christ's call for us to lay down our lives for others. This book is a timely and noteworthy gift."

Sharon Garlough Brown, author of the Sensible Shoes series and *Shades of Light*

"From the faithful and artistic genius of Vincent van Gogh to the passionate and insightful teachings of Henri Nouwen, this light-filled book is a must-read for everyone. A personal glimpse into the author's shining examples of living the compassionate life gives intimate and amazing insight into loving our neighbors as ourselves. A colorful and brilliant work about love and genuine concern that bring van Gogh and Nouwen to life as servant leaders to humanity."

Jane A. LoBrutto, licensed minister and administrator

"Carol Berry, artist, storyteller, and theologian (my words not hers), invites us to journey into the transcendent, intersecting worlds of Fr. Henri Nouwen and Vincent van Gogh by recreating the experience of the only seminar by Fr. Nouwen on 'The Compassion of Vincent van Gogh.' I believe Henri to be one of the most, if not the most, profound and approachable spiritual guides of the last century, and Vincent an equally similar guide through his art. Carol's work sheds light on lesser known aspects of Vincent's life and vocation and at the same time invites us to reflect on our own lives as Henri evoked the compassionate way, moving from the solidarity of suffering to consolation and then to comfort. Carol is refreshingly honest in telling her experiences with both Henri and Vincent but in ways that invite the reader to look more deeply into their own experiences and 'see therein the presence of the divine.' This compelling work will appeal to a broad audience in many fields."

Phillip N. Grigsby, executive director of Schenectady (NY) Community Ministries, former president and a founding member of Capital Region Theological Center

"In her recent book, Carol Berry has created a place where art meets life and a new compassionate life emerges. She learns from two artful men of great compassion, artist Vincent van Gogh and theologian Henri Nouwen. It was what she learned in Nouwen's course on van Gogh at Yale Divinity School, and Carol's own subsequent research about the artist, that eventually spilled over into her own life experiences and gave her a new lens of compassion through which to filter all of it. The vignettes she relates from her own life as an artist and from her ministry witness to a life that is met on its own terms. She doesn't try to manipulate the details. She enters the life that is given to her at any moment and is transformed by it. Some may use the word *serendipitous* to describe the interweaving of the events of her and her husband's lives; she may call it *providence*."

Jo-Ann Iannotti, photographer, poet, and author of *Remember, Return, Rejoice: Journeying from Ash Wednesday to Easter Sunday*

Foreword by Sue Mosteller, CSJ

Learning from Henri Nouwen & Vincent van Gogh

A Portrait of the Compassionate Life

—H—

Carol A. Berry

IVP Books

An Imprint of InterVarsity Press
Downers Grove, Illinois

InterVarsity Press
P.O. Box 1400, Downers Grove, IL 60515-1426
ivpress.com
email@ivpress.com

InterVarsity Press® is the book-publishing division of InterVarsity Christian Fellowship/USA®, a movement of students and faculty active on campus at hundreds of universities, colleges, and schools of nursing in the United States of America, and a member movement of the International Fellowship of Evangelical Students. For information about local and regional activities, visit intervarsity.org.

All Scripture quotations, unless otherwise indicated, are taken from The Holy Bible, New International Version®, NIV®. Copyright © 1973, 1978, 1984, 2011 by Biblica, Inc.™ Used by permission of Zondervan. All rights reserved worldwide. www.zondervan. com. The "NIV" and "New International Version" are trademarks registered in the United States Patent and Trademark Office by Biblica, Inc.™

While any stories in this book are true, some names and identifying information may have been changed to protect the privacy of individuals.

Excerpts from previously unpublished and certain published material written by Henri Nouwen are included here with the permission of the Henri Nouwen Legacy Trust. Unpublished material is contained in the Henri J. M. Nouwen Archives and Research Collection, University of St. Michael's College, Toronto, Ontario, Canada.

Cover design: Autumn Short
Interior design: Jeanna Wiggins

Cover images: garden in bloom: © Garden in Bloom, Arles by Vincent van Gogh /
 Private Collection / Bridgeman Images
 grunge paper: © IntergalacticDesignStudio / E+ / Getty Images

ISBN 978-0-8308-4651-1 (print)
ISBN 978-0-8308-7272-5 (digital)

Printed in the United States of America ♾

InterVarsity Press is committed to ecological stewardship and to the conservation of natural resources in all our operations. This book was printed using sustainably sourced paper.

Library of Congress Cataloging-in-Publication Data
A catalog record for this book is available from the Library of Congress.

P	18	17	16	15	14	13	12	11	10	9	8	7	6	5	4	3	2	1
Y	33	32	31	30	29	28	27	26	25	24	23	22	21	20	19			

This book is dedicated to my sons
Andris, Mathias, and Kristof.

Like Vincent and Henri,
they seek to live by following their conscience,
often going against the grain but always
offering blessings of compassion
along the way.

CONTENTS

FOREWORD

Sue Mosteller, CSJ

Spiritual yearning . . . has brought me calm,
peace, prayer, compassion, and forgiveness—
so I have received joy and freedom.

RICHARD WAGAMESE, *EMBERS*

Reading this book, my eyes welled with tears as I toured it like an art gallery of portraits and images portraying the spiritual yearnings in the lives of the author, Carol Berry, and her not-nearly-perfect but precious friends, Vincent van Gogh and Henri Nouwen. Tears also came when I was absorbed by the artists' letters and stories that so vividly portrayed my own soul-felt yearnings and connected with the pain I encounter in life. Pouring over this perfectly subtitled book, *A Portrait of the Compassionate Life*, felt like walking through an art gallery. I was compelled to stop; step "into" each work of art; gaze; note the detail, color, darkness, and light; and allow my heart to feel how human anguish ever so gradually mutated into compassionate living. This, I strongly believe, is the only way to read this book!

As the author, Carol becomes the tour guide for readers who also spiritually yearn to grow in compassion. She is unique and the only person who could pen a book of such feeling and depth. During the past forty years, she has cared pastorally with her husband, Steve, for his parishioners in wealthy and poverty-stricken churches across the country.

In her efforts to be further inspired by her two friends, Carol has studied Vincent's letters and, in the middle of the night, looked long and hard at Vincent's paintings. With exceptional passion, she has thoughtfully confirmed her knowledge of, and friendship with, Henri Nouwen's life story from friends and his more than forty books. Mother of three beloved sons, she is an accomplished artist and art instructor, having offered countless retreats and workshops on the lives and ministries of van Gogh and Nouwen. To meet Carol is to encounter the influence of her brother-artists in the flesh. I have known her for twenty-five years, and she is, for me, an example of mercy and compassion, a beloved sister who touches my life with beauty and love.

This is not a book about ideas or a theological treatise but a book of living portraits of people whose hearts, like ours, have been molded in a broken world by a wide range of experiences such as love, fear, hope, despair, pain, care, and yearnings for power or compassion. It is a true story, and one that invites us to identify painfully and hopefully with its subjects. Each portrait draws us into our own deepest heartfelt aspirations designed in the image of God for our living in an imperfect world.

The book you hold is more than a book. It is a revelation! Studying the portraits, examining the letters, and reading the stories, one enjoys the rare privilege of personally identifying with both the vulnerability and the power revealed in hearts where compassion was born from anguish. The artists become guides and shepherds, tracing the universal pathway to human tenderness and understanding.

Richard Wagemese's spiritual yearnings, quoted above, eventually brought him calm, peace, prayer, compassion, and forgiveness, resulting in joy and freedom. I trust and believe that Carol and her friends bring comfort to the painful longings in our vulnerable hearts. May your tour of this unique gallery of transformation become a fruitful journey into your heart's desires!

INTRODUCTION

Encountering Henri and Vincent

We almost didn't go to New Haven, Connecticut, in autumn 1976. My husband, Steve, was sitting at the kitchen table in our little parsonage in northern Vermont one late summer day that year when he opened the anticipated envelope from Yale Divinity School. The first sentence began, "We regret to inform you . . ." Without reading any further, he tossed the rejection letter into the empty fruit bowl.

While working toward his undergraduate degree, Steve had served as a licensed student pastor for three years in two rural parishes in northern Vermont. At the insistent encouragement of a retired clergy friend, a Yale alumnus, Steve had applied to Yale Divinity School. It was the only application he sent. Expecting to move by the fall after his graduation from Johnson State College, he informed the two parishes of our intention to leave. When the letter arrived, we had just a few more weeks of parish ministry left with no plan B. And on top of that, I was entering my ninth month of pregnancy with our first child.

A week went by before Steve finally did retrieve that missive from the fruit bowl and read it through to the end. And there it was—the chance that we had almost missed. The concluding paragraph stated that Steve should inform the Yale Admittance Committee by return mail if anything in his application had been overlooked or misunderstood. Steve immediately contacted Yale Divinity School again. This time he submitted examples of sermons he had preached, including a detailed account of

our three years' parish experience. For good measure he added a list of all the books he had read while preparing his sermons. Within another week and a half Steve received an acceptance letter. A few days later he was on his way south with a U-Haul, transporting our few belongings to student housing on the Yale Divinity School campus in New Haven.

Life during the initial months on campus couldn't have been more different from our parish life with the rural folks up north. For me the days were filled with the wonders and challenges of caring for our baby boy, Andris. Meanwhile, Steve couldn't seem to find his bearings in the competitive atmosphere of academia. Further, he felt that after his experience of a hands-on ministry, the academic setting seemed artificial and not in touch with reality. He could barely open his books and was falling drastically behind in his course work. He began questioning whether he had made the right choice to enroll in divinity school—until he met Henri Nouwen, who was at that time a professor at the Yale Divinity School.

My first meeting with Henri Nouwen is still very vivid in my mind. Stepping into the Yale Divinity School bookstore one day, my ears immediately picked up an unmistakably Dutch accent spoken by someone on the other side of the bookshelves. Following the sound, I saw a man dressed in a well-worn, baggy, moth-eaten sweater with a woolen scarf around his neck. His hair was disheveled. He had thick glasses perched on the tip of his nose and was carrying an armload of books. He looked like the typical student, somewhat older than the rest maybe, but definitely one of those studious types who neglect everything else except their studies. Eager to meet a fellow European (I grew up in Holland and Switzerland), I approached him and asked, *Studeert U hier* (Do you study here)?

Without letting me know that I just made a faux pas, he simply said, *Nee, ik geef hier les* (No, I give lessons here).

Thankfully, this short dialogue had been spoken in a language no one else likely understood, so my mistaking one of Yale Divinity School's

most distinguished professors for a mere student had no witnesses. Henri just looked at me kindly with those big eyes of his, and our friendship began.

COMPASSION AND VAN GOGH

During the second semester Steve enrolled in Henri's course called "Compassion"—a practical, nontheoretical class meant to prepare seminary students for the actual life of parish ministry. Henri based the core of his teachings in this course on the Scripture passage from Paul's letter to the church at Philippi: "There must be no competition among you, no conceit; . . . always consider the other person to be better than yourself" (Philippians 2:3 JB). As Henri and the students deliberated on Paul's words, Steve realized that this Scripture contextualized many of the experiences he had had during the three years of parish life. Henri helped Steve become aware that he was actually far ahead of his colleagues in this particular class. Steeped in a practical ministry, Steve had witnessed compassionate living firsthand, exemplified in countless interactions within the lives of our rural parishioners.

At Yale Divinity School, the "Compassion" course remained the most meaningful class Steve attended. In Steve's words, "It turned out to be the singularly most important class that I ever took in all my years of schooling either before Yale Divinity School or after." Thanks to Henri, Steve felt his call to ministry affirmed. For the next two years Henri became Steve's mentor and offered him one of his teaching-assistant positions.

Today, Henri is primarily known as an author, but in the mid-1970s Henri's focus was on preparing seminarians for the Christian ministry. Henri the author was first Henri the pastor and teacher. During his professorship at Yale Divinity School, a focal theme of his teaching was on how to reach out compassionately in settings of parish ministries wherever these parishes would be. There was a need for more compassion in the country. We had just ended the Vietnam War, racial

tensions were high, and so was the nuclear threat. There was a great deal of violence on many levels of society. What is compassion? Henri asked. Compassion, he said, was best understood by a desire to serve and by entering into the suffering of another. To be compassionate, one had to become present to the other. One had to be willing to walk with, sit with, cry with, and bind the wounds of the other; being compassionate means literally to suffer with.

Steve discovered that Henri was going to teach a similar class the following semester with limited enrollment, this time focusing on the artist Vincent van Gogh as a case study for compassionate living. He immediately suggested that I audit the class. Loving art and being an aspiring artist, I didn't need to be coerced. I, like Steve, entered into an experience that would eventually guide me in my life's vocation.

Henri introduced his class "The Compassion of Vincent van Gogh" with these words:

> Here we are—people who want to prepare for the ministry. What do we want to do as ministers? Well, one thing is sure: We want to give strength to people in their daily life struggles. Many people have done this, and we often reflect on their lives for inspiration. I should like to introduce to you a man you have often heard of but not as a giver of strength, not as a minister. . . . It is the Dutch painter Vincent van Gogh.[1]

Henri's aim was to create a space and time where a true encounter with Vincent could take place.

Those of us who were familiar with Vincent van Gogh knew him primarily as an eccentric and deeply troubled artist who ended his own life at the age of thirty-seven. According to popular understanding, Vincent was first of all a social outcast. He was also a man who drank alcohol excessively at times. He visited brothels. I wasn't the only one asking myself, how could someone with this character become a case study in a class at a theological seminary? How could future pastors learn about

living a compassionate life from a man who was disagreeable, prone to bouts of melancholy, and, some of us knew, had chosen to live with a prostitute? How could someone with such apparently great flaws teach us about anything? We all were curious. How did Henri come to hold this artist in such high esteem? How would Henri hope to make us understand Vincent's broken life and use this life to teach us about compassion? What made Henri say that the longer he lived and tried to make sense out of his own struggles, the more he found in Vincent a kindred spirit? For, Henri said, when he had felt lonely, Vincent had become his companion, someone he could identify with. Henri told us that Vincent had touched him deeply from within just as Thomas Merton had—by putting him in touch with parts of himself that he hadn't been able to reach. But, really, we wondered, how could Henri reach the conclusion that Vincent van Gogh was his saint?

MISUNDERSTANDING VAN GOGH

There is much written on Vincent van Gogh from the point of view of art history and psychoanalysis but very little about his spirituality. Henri, who had studied psychology at the Menninger Clinic, disagreed with what he basically saw as caricatures of van Gogh. The experts in the art world, Henri noted, portrayed Vincent as a psychologically disturbed, mentally imbalanced, and crazy artist. Henri asked us to consider why, if Vincent was so crazy, were people from all walks of life drawn to him? Was he really crazy? What were people neglecting to understand? Were they willfully ignoring the realities that Vincent was obsessed with—such as care for the poor? Most people did, for it took a more in-depth study of Vincent's life to discover those realities.

Henri had decided to devote much time to getting a closer look at this artist when he visited his native Holland. While in Amsterdam, he entered the newly opened Van Gogh Museum (which had opened in 1973). This museum houses the largest collection of Vincent van Gogh's art in the world, arranged in chronological order. Here Henri

could walk along a visual time line of Vincent's ten years of artistic life displayed on the walls of the museum. This experience of viewing Vincent's work almost in its entirety is only possible in the Van Gogh Museum, and this was crucial in discovering that Vincent's mission was to use art as an expressive language.

The art critic Maurice Beaubourg is quoted as having written, "One shouldn't look at just one painting by Mr. Vincent van Gogh, one has to see them all in order to understand."[2] Henri looked at Vincent's early sketches depicting the rural and urban poor and the somber interiors of peasant cottages in Holland. He then continued on to the sun-drenched landscapes created in the south of France. He became increasingly aware of the artist's intention to have his art give voice to his feelings rather than to reproduce only what he saw. The sequential course of Vincent's work elucidated the artist's attempts to develop an art that spoke, that communicated, and that would touch people.

During that museum visit, Henri also had an encounter with Vincent's nephew, Dr. Vincent van Gogh, who had been instrumental in the establishment of the Van Gogh Museum. Henri asked him why so many people flocked daily by the thousands to look at his uncle's paintings. What was it about Vincent that touched a chord that resonated deeply within us? Henri related Dr. van Gogh's answer: "Because people feel comforted and consoled. Vincent was able to crawl under the skin of nature and people and find there something truthful, something beautiful, something joyful, and something worth seeing. He was able to draw out the inner secret of what he saw."[3] This response affirmed Henri's own sense that Vincent's art did not merely satisfy aesthetic demands but sought to connect with people in a profound way.

The words of Dr. van Gogh stayed with Henri as he began a fascinating and soul-enriching journey into Vincent's life and art. Henri developed a deep bond with Vincent after reading the artist's extensive and very private correspondence, mostly to his younger brother Theo. These letters, as we would come to discover, form a

most unique document, not only in the history of art but as a profound literary testament of the life of a wounded healer. Vincent had hoped to comfort through his art, but his letters have that effect too. We would come to understand why Henri identified with Vincent. They both shared the desire to reach suffering people with messages of reassurance and hope. And just like Vincent, Henri hoped to touch lives through his creative work. Just as Henri strove to live the faith of Jesus, so too did Vincent.

What left a deep impression on Henri was that, despite Vincent's many rejections and failures, Vincent retained this tremendous inner drive and desire to comfort and touch people through a language that could be universally understood. In our class Henri explained, "Vincent offers hope because he looks very closely at people and their world and discovers something worth seeing."[4] Vincent wanted to offer comfort because he had been willing to crawl under the skins of others and discovered that he shared the same human condition. Henri recognized that Vincent was an artist with a mission, as well as a prophet and a mystic. Vincent was above all a compassionate man. This book is about Henri's insights into Vincent's life from the course "The Compassion of Vincent van Gogh."

AN ONGOING FRIENDSHIP

My last encounter with Henri at the divinity school happened in a very different setting from my initial meeting. I was in the hospital with my day-old second son, Mathias. Still exhausted after the birth and happily settling into nursing my little son for the first time, I was not expecting any visitors. But then, quite abruptly, the door to my room swung open and there was Henri. No time to put on a robe or comb my hair. Nothing deterred Henri from what he had come to do—to bless our little child. So with his warm, large hand, Henri reached over, placed it on Mathias's head and blessed him. In the years to come, our encounters with Henri, mostly by letter, were just as natural, as spontaneous, and as moving.

We always connected through ordinary moments and situations, which in turn became blessings every time.

Two weeks after Henri's visit to the hospital, Steve, Andris, Mathias, and I left for St. Louis, Missouri, where Steve's first job after graduation was taking us. Steve had told Henri that we wanted to go back to serve a little rural church in Vermont. Henri urged Steve to seek an inner-city ministry instead. So that is what we did and where we went to resume our ministry after the three years of student life. The inner-city, biracial church in St. Louis was a far cry from our first two rural parishes in northern Vermont! There, our third son, Kristof, would be born. After three years there, we continued our parish ministry in large inner cities for twenty more years, first in New York City, then in Los Angeles. In 2001 we came full circle by returning to Vermont to serve in a village church.

During the years of our urban ministries, we were honored and happy to be able to welcome Henri several times into our home as our friend and workshop leader. We also traveled to visit Henri at the L'Arche Daybreak community in Toronto, where Henri served as spiritual director after leaving academia behind. At L'Arche we perceived Henri's love for the core members and witnessed their love for him. He was at L'Arche to pastor these men and women with mental and physical infirmities, but he was also an active participant in the day-to-day life of caretaking. Henri continued to inspire us through his compassionate outreach, his guidance, and his wisdom, much of which reached us through his many books. Then in 1996, on a Sunday after our church service in our Los Angeles parish, we were shocked and saddened to receive the news of Henri's sudden death. Steve flew to Canada and was among more than a thousand people who joined together in a memorable and profoundly beautiful celebration of Henri's life and ministry. Steve was overwhelmed by the great outpouring of love and gratitude that filled the Cathedral of Transfiguration in Markham near Toronto. The many core members of the L'Arche community who had

been touched and blessed by his life encircled Henri's simple pine casket. It was covered by an abundance of glorious sunflowers paying homage to Henri but also alluding to his bond with the artist Vincent van Gogh, who had affected him so deeply.

THE BEGINNINGS OF THIS BOOK

A few years after Henri's death I was contacted by our dear friend Sister Sue Mosteller, Henri's literary executor and spiritual director, because she knew I had attended his class "The Compassion of Vincent van Gogh." Since he had never published a book based on his lectures, Sue hoped that I would do something with all the course material she had sent to me with the instructions: "Write the book!"

Reading through Henri's notes reawakened in me the excitement and passion I had felt years before sitting in his classroom. For the last twenty years I have publicly presented Henri's and Vincent's words and Vincent's paintings in numerous workshops and lectures, focusing on Henri's message of compassion as exemplified in the life of his saint.

Henri revealed to us in his course that when one reads Vincent's letters and contemplates his paintings, three aspects of compassion come into focus. Henri said, "When we say blessed are the compassionate, we do so because (1) the compassionate manifest their human solidarity by crying out with those who suffer, (2) they console by feeling deeply the wounds of life, and (3) they offer comfort by pointing beyond the human pains to glimpses of strength and hope."[5] These three stages—the progression from solidarity to consolation to comfort—which Henri felt contributed most significantly to living compassionately, define the structure of this book.

In the pages that follow, Henri and Vincent will speak with their own words in the first two chapters of each part. (Any uncited Nouwen quotes are from the course lectures.) Henri's and Vincent's ministries and guidance have made me more conscious of the ways Steve's and my lives have been touched by grace and compassion. My own stories

and reflections form the third chapter in each part. They are taken from ordinary moments of our parish life together, which have again and again pointed beyond the human pains to glimpses of strength and hope.

Henri told us at the beginning of his course on compassion that we would attempt to reach another level of discourse about Vincent van Gogh. We knew how to talk about art and psychology; we now would have to find ways to speak about Vincent's ministry. Henri felt that by studying one man's life and work, we could touch on many subjects. Such an intimate involvement with Vincent would also help us grow and learn more about ourselves. We had to make space within us for his story to connect with our stories. My hope is that my encounters with Henri and Vincent and with the people from our different parishes will enable you to recognize more fully the moments when you too were touched by grace and compassion.

Part One
Solidarity

The compassionate manifest their
human solidarity by crying out
with those who suffer.

HENRI NOUWEN

I believe that, after all, I have
done nothing or shall never do anything
that would have had me lose or make me
lose the right to feel myself a human
being among human beings.

VINCENT VAN GOGH, NUENEN,
C. JANUARY 4, 1884

Vincent Cries Out with Those Who Suffer

enri's classes were not so much presented to us as lectures but as opportunities to gain insight into our own selves, our own struggles, through the channel of a life fully revealed through art and letters—through the life of Vincent van Gogh. Henri believed that the intensity of Vincent's struggles as expressed in his letters and paintings could offer a unique case for reflection and discourse. No one had studied Vincent from the perspective of art as ministry. And yet Vincent addressed questions in his letters and through his paintings that are centered on ministry—questions about suffering and death, about immortality, forgiveness, and redemption; questions about poverty, loneliness, and despair, as well as about conscience, compassion, and hope. Vincent strove for a greater understanding of the spiritual dimension in life. He wanted to have a clearer view of how art and religion both had the power to console. And he hoped to reveal how the creative experience can lead to a greater love for creation and each other.

Henri did not expect us to become van Gogh experts but to remain in a receiving mode while contemplating Vincent's life and art. Our receiving mode was to be a truth-searching approach rather than a curiosity approach to Vincent's life. We were invited to see Vincent in such a way that his life and work would be windows through which we could see a glimpse of truth. We were to apply a particular way of knowing: knowledge of the heart. We had to learn Vincent by heart. This, Henri

believed, would allow us to see Vincent in a new light and be less dis-turbed by his failings and unconventional behavior. With the insights gained from Vincent's life, Henri hoped we could acknowledge our own needs and use our own weaknesses and failings to become more cre-ative and effective communicators, comforters, and healers. As the course progressed, we did become increasingly inspired by Vincent, who made us realize that precisely through understanding our own inade-quacies and vulnerabilities we could identify and connect with others.

Henri asked us to read selected letters from the more than nine hundred Vincent had written, most of them to his brother Theo. In these letters we discovered a man who was far different from the image we had previously formed of him. As we read his personal reflections, we were immediately drawn into his expressions of passion and honesty; we were affected by his wisdom and his frailties, and above all, by his longing to love and be loved. Despite his excitable, moody, and complex character, we realized that Vincent had been a man with deep and tender feelings. And we realized this is precisely what Vincent wanted us to understand.

Through over a hundred slides we became familiar with Vincent's early drawings and then were captivated by the vitality of his brush strokes and vibrant colors of his paintings done toward the end of his life. The visual language Vincent had worked so hard to develop became another expressive dimension of his writing. Vincent's moti-vation to create art stemmed from his personal needs for love and hope and connectedness. Henri was driven to write and teach by the same desires. Both Vincent and Henri recognized these identical yearnings in others. Henri had been drawn to Vincent because he recognized the same life struggles and questions in himself and in the students he taught. Henri also found that Vincent did not run away from his own painful condition or avoid looking at and confronting his own self. Out of the awareness of his own suffering and deep longing for love and comfort, Vincent sought to reach out and alleviate the suffering he witnessed in those around him. Discovering this reality about Vincent

brought Henri to recognize Vincent's compassionate nature. To us it would become clear that Vincent had become a guide and teacher to Henri and that Henri's class was fueled by his intimate knowledge of this artist's life. In Henri's course, the artist became simply *Vincent* to us too—a friend who felt deeply and tenderly, who revealed the same struggles, searched like us for meaning and purpose in life, and taught us so much about living compassionately.

Henri, with his Dutch accent and his impassioned manner of engaging us, almost began to take on the temperament of Vincent for us. Not that he intended to, but as he spoke to us by quoting Vincent's letter, the two voices often became one and the same. Everything in that course—Vincent's paintings, Vincent's letter dialogues with his brother Theo, and Henri's fervent teaching—reverberated with the same passion, honesty, and urgency. It all touched us deeply, emotionally and spiritually. Had I just continued looking at van Gogh's art in museums on my own, it would have never led me to discover the artist's soul in such depth. Henri offered us a unique opportunity to engage and become familiar with Vincent in a much more intimate and personal way.

PASTORAL BEGINNINGS OF SOLIDARITY

Henri disclosed to us that Vincent's initial fervent desire had been to become a pastor, not an artist. After failing in the career chosen for him by his family, an art dealer, he decided to follow his father's footsteps. His father was a respectable Calvinist parson of small country churches in the south of Holland. He fulfilled the role of a traditional parish cleric, somewhat segregated and limited by expectations and religious customs of his day. The parsonage physically set the parson's family apart from the common life of the villagers. But Vincent didn't want to be that kind of pastor or do that kind of pastoring from the vantage point of privilege.

Vincent rejected being set apart, something that generally comes with ordination to the priesthood or ministry. Instead, he wanted to

enter into the experience and the condition of those he served just as Jesus had done. He aimed to authentically embrace those who suffered, to live among them, endure their experiences, and work as hard as they did. He believed in living in an integrated manner rather than remaining separated by the dictates of social standing. But such intimate involvements with his parishioners, he would come to find, brought about great suffering and often loneliness, and in his case, rejection by the institution he served.

In one of his earliest classes, Henri showed us a slide of a drawing by Vincent of a landscape with pollard birch trees that had been stunted (pollarded) in order to produce new, straight branches; such trees grow along many of the alleys throughout Holland. It was a sketch Vincent had made early in his artist's vocation. The rows of pollarded birch trees, their bare new-growth branches reaching skyward, stand on ground that is covered with tufts of dry reed-like weeds. The trees form a barrier separating two dark peasant figures partly silhouetted against the light background of the sky. They both seem to walk away from the viewer, one herding his sheep before him.

It is a bleak image of loneliness. Henri showed it to illustrate that a compassionate and involved ministry can be a lonely venture. He told us that we would often suffer from isolation in our future ministries

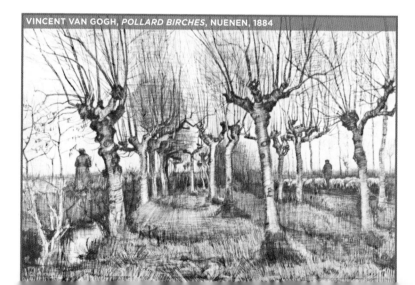

VINCENT VAN GOGH, *POLLARD BIRCHES*, NUENEN, 1884

despite being surrounded by human beings, human beings often desperately seeking a comforting relationship. It is often enormously difficult to reach a level of solidarity where trust and intimacy lead to such a relationship. By drawing our attention to this sketch, Henri introduced us to Vincent's ability to do drawings that related feelings and emotions. Through such drawing Vincent could express a universal kind of loneliness that he experienced. Henri called it "cosmic loneliness."

To add to our understanding of Vincent's narrative language, Henri used the artist's descriptions of this kind of isolation taken from one of his early letters. At the time when Vincent wrote these thoughts, he was living among destitute miners in an impoverished mining district of the Borinage in Belgium. After having failed in his attempt to study theology and become a pastor like his father, Vincent had nevertheless found a way to minister and preach the gospel to the poor, namely, by becoming an evangelist missionary instead. This is what led him to the miners in the Borinage. Out of his desperate struggle to effectively find ways to connect with them, he wrote,

> Someone may have a great fire in his soul, yet no one ever comes to warm himself at it, and the passers-by see but a little smoke coming out the chimney, and continue on their way. Look here, now, what must be done, tend that inner fire, have salt in oneself, wait patiently yet with how much impatience? Wait for the hour, I say, until someone will come and sit down, to stay?[1]

Henri had experienced this sense of difficulty in achieving intimacy and solidarity many times throughout the course of his own life. It was a quote that meant a lot to him since he could identify with the "desire to embrace the world" and yet "the passers-by see only smoke coming out of the chimney." In time, Henri learned that the effort to reach out in a compassionate way would first require a level of oneness with the passersby where the barriers of defensiveness and mistrust had to be dissolved. The solidarity Henri was talking about

had to grow "mature by waiting patiently and by faithful adherence to the great call to be the same, yes, more of the same. And that's the first step of compassion." Vincent's time in the Borinage could teach us about responding to the call of a solidarity needed in order to connect with the passersby.

SUFFERING SERVICE

During the first weeks of our course we discovered that Vincent had always been drawn to people who suffered. Even as a young boy, he was deeply moved when he accompanied his father to the homes of parishioners and saw people living in poverty and misery. When he was a missionary-in-training in the Belgian mining district, he went a step further than his father had. In the Borinage, Vincent put himself deliberately in a position of sharing in the miners' hardships by rejecting the privileges afforded him as an evangelist; he gave up his comfortable housing, adequate clothing, and nutritious food. He felt that in order to understand his role as minister of the gospel to the poor, he had to endure the same deprivations and circumstances as his parishioners. Only out of his own familiarity with anguish and pain could he find ways to respond to the needs of those who suffered such hardships. Only by experiencing the basic living conditions could he realize what his parishioners lacked.

With such experiential understanding, he could attempt to "do unto others as you would have others do unto you" (Matthew 7:12; Luke 6:31 paraphrase). Henri emphasized that in Vincent's life, suffering with the other had specificity. One heard a great deal about entering into the pain of others, but this was ephemeral and somewhat dreamy and unreal. Vincent's response wasn't a vague suffering with all humanity or joining into the suffering conditions of a hurting world. Rather, Vincent's experiences and Henri's teachings were aimed and focused on the needs of those in our immediate surrounding. Henri hoped to show us with the example of Vincent's life a real and specific way of

entering into the human condition of a person in need. Henri wanted to make the truth of compassionate living tangible and doable.

Henri affirmed that "when you realize that you share the basic human traits with all humanity, when you are not afraid of defining yourself as being the same and not different," you have reached a place of commonality, a place where the burdens of life can be shared. The word *compassion* means "to suffer with." "Compassionate persons, therefore, are, first of all, persons who confess their part in the suffering human condition and are willing to recognize that the anchor hold of their identity is in the common experience of being human."[2] Vincent searched for that solidarity, that common experience, when he lived among the poor, be it in rural or in urban environments. It demanded his all; it brought him through great deprivation, loneliness, and suffering, but it led him to an honest and deep solidarity.

Henri had used the Scripture passage from Paul's letter to the church at Philippi in his previous class on compassion to affirm the call for this type of solidarity:

> If our life in Christ means anything to you, if love can persuade at all, or the Spirit that we have in common, or any tenderness and sympathy, then be united in your convictions and united in your love, with a common purpose and a common mind. That is the one thing that would make me completely happy. There must be no competition among you, no conceit; but everybody is to be self-effacing. (Philippians 2:1-3 JB)

In Vincent's vocation as minister of the gospel to the poor, Henri found him to indeed take literally the words of Paul: "Always consider the other person to be better than yourself, so nobody thinks of his own interests first but everyone thinks of the other people's interests instead. In your minds you must be the same as Christ Jesus" (Philippians 2:3-5 JB).

Years after his missionary work with the Belgian miners, when Vincent made the transition from missionary to artist, he still sought the

same kind of close relationships that he had experienced in the Borinage. He still hoped that passersby would see the "little smoke coming out the chimney" but then "come and sit down, to stay." One way he could ensure that people would come and sit down near him was to invite those he shared his life with to become the models for his studies of the human figure.

Vincent asked the peasants in the countryside and the poor of the city almshouses to pause a while, to spend some time with him while he sketched them. The effort of observing and drawing them connected him to his subjects and allowed him to experience kinship and companionship.

Henri showed us examples of figure sketches as a visual proof of his strong desire to share his inner fire with the passersby. Vincent had hoped that one day he would be able to express in his work the sincere feelings his subjects elicited in him, which was not an easy task. While mastering the skill of drawing from observation was accomplished through persistent practice, imbuing those outlines and shapes with personal feelings and the subjective expression of the sitter was a whole other dimension of art that did not only depend on correct rendering.

At the beginning of his artist's path, when Vincent asked himself, *What is drawing?* he used a metaphor to explain the difficulty of achieving an art of solidarity that would convey more than an observed fact. He wrote that drawing is working oneself through an invisible iron wall that seems to stand between what one feels and what one can do.[3] Henri said that for Vincent, and anyone trying to reach compassionate solidarity, it was also "like breaking through an iron wall. This was excruciatingly difficult, but also exhilaratingly beautiful when one succeeded."[4]

HENRI AT L'ARCHE

Throughout his career, Henri spoke about his own difficulty of breaking through that iron wall. Such a breakthrough was an ongoing struggle. Years after teaching his course on compassion and Vincent, and after he had spent time in South America and had been a professor at

Harvard, Henri traveled to Canada, where he was invited by Jean Vanier to visit L'Arche Daybreak in Richmond Hill, Ontario. Jean Vanier is the founder of the L'Arche communities worldwide, which are dedicated to welcoming and caring for people with intellectual and physical disabilities.

Henri had longed for a place he could call home, and he finally put down his roots in the L'Arche Daybreak community of Richmond Hill. He became the spiritual director, ministering to the staff and the core members. In this community Henri could leave behind the stressful, competitive academic atmosphere and live unencumbered by worldly achievements and expectations. His accomplishments in life, his degrees, his ordination, and his authorship meant little to the people he had come to live with and care for. To his new family he was simply *Henri*.

The men and women of the L'Arche community recognized and responded to Henri's love, which came from a place of solidarity and trust. Just like Vincent in the Borinage, Henri lived among the men and women at L'Arche; he ate with them, fed them, dressed them, and comforted them. In his new home Henri was willing to let go of all that had defined him in the past and simply become a family member. This is how Henri came to experience a most intimate solidarity—years after he had revealed such solidarity with his students through the life of Vincent. While living among the most broken in society at L'Arche, Henri received, just like Vincent had, unique offerings of wisdom and valuable lessons. Henri found deep friendships, unconditional love, and acceptance. Once Henri had worked himself through that iron wall of initial separation, he had become a comforting, enriching presence. Henri expressed what it felt like to break through that iron wall—to go from detachment to solidarity—in *Bread for the Journey*, published in 1997, twenty years after teaching his Compassion class at Yale:

> Joy is hidden in compassion. The word *compassion* literally means "to suffer with." It seems quite unlikely that suffering with another person would bring joy. Yet being with a person in pain, offering

simple presence to someone in despair, sharing with a friend times of confusion and uncertainty . . . such experiences can bring us deep joy. Not happiness, not excitement, not great satisfaction, but the quiet joy of being there for someone else and living in deep solidarity with our brothers and sisters in this human family. Often this is a solidarity in weakness, in brokenness, in wound-edness, but it leads us to the center of joy, which is sharing our humanity with others.[5]

Henri understood that the solidarity ministers need to seek is the solidarity Vincent sought. "And here there really is no difference be-tween the minister and the painter. Both want to touch people and both feel the pain of the distance that often is so hard to bridge" in the be-ginning.[6] Henri recognized that Vincent was breaking down walls of separation because he was following the way of Jesus. He was not concerned with doctrine or dogma or theocratic correctness but simply with responding immediately, lovingly, and caringly to the predicament of another human being. This too is the way that Henri embraced his life and ministry.

A Time of Solidarity

Vincent spent his early years in the south of Holland, in a rural province called Brabant. He was a solitary child and often escaped the confines of his parents' busy and strictly controlled household to spend countless carefree hours roaming the heath or walking along country lanes. The air was filled with the earthy scent of the ploughed, dark soil or freshly mowed hay. He was sometimes drenched by wind-driven rain or chilled by the cool, misty ocean breezes that blew incessantly over the lowlands.

Vincent came across farmers going about their seasonal labors of sowing and reaping or the peat diggers and common laborers eking out their daily subsistence. With a keen sense of observation, he was always on the lookout for birds' nests, insects, or new growth along the furrows of the plowed fields. Everything sparked his enthusiasm and his imagination. He didn't know it then, but he was already an artist in training—colors, smells, sounds, shapes, and the distant horizon line of the flat Dutch landscape created the wealth of images and memories that would feed his art one day. Years after he had left his rural home, he wrote to his brother Theo, "I hope there will always be something of the Brabant fields and heath in us."[1] Numerous letters contain references to his growing-up years, and he remained convinced that if one wants to grow, one has to be planted in the earth.[2]

Vincent was aware that a creative power was at work throughout nature. At a young age he developed a deep reverence for all of life.

Many years later he would call the force that permeated everything around him the "Something on High," a term he was to glean from reading books by Victor Hugo. Nature, he was also taught, was the book through which God revealed his truth and love. Vincent's sister Elizabeth, reminiscing about her brother, said that "with a thousand voices nature spoke to him, while he listened" with his soul.[3] Vincent would eventually translate what nature revealed to him with written and painted metaphors and symbols. The landscape paintings he created in the last few years of his life all point back to the deep love and strong connection he had with the lands and the people of the Brabant. Vincent acknowledged the influence his rural past had on him in a letter to Theo, written after he had begun to paint:

> Many landscape painters don't have that intimate knowledge of nature which those have who looked with sentiment at the fields from childhood on. . . . You will say, but everyone has surely seen landscapes and figures since they were children. Question: was everyone also thoughtful as a child? Question: did everyone who saw them—heath, grassland, fields, woods—also love them, and the snow and the rain and the storm? Not everyone has done that the way you and I have; it takes a special kind of environment and circumstances that have to contribute to it, and also a particular kind of temperament and character to make it take root.[4]

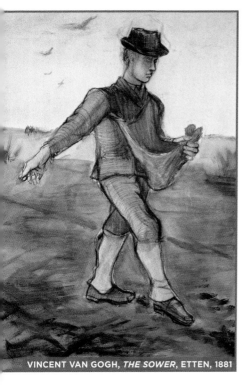

VINCENT VAN GOGH, *THE SOWER*, ETTEN, 1881

Wherever his path would lead him once he left his childhood home, he remained a country boy at heart. All that Vincent achieved as an artist had its beginnings in the fertile fields around Zundert in the Brabant. In a sense, the damp Dutch soil was the matrix from which the planted seeds would one day burst forth into the brilliant sunflowers of the South.

SEEING WITH HOLIER EYES

Vincent had not only been planted in the fertile soil of the Brabant but also into a religious home. Since his father was a Protestant pastor, Vincent and his siblings were brought up in a pious and virtuous home. His parents modeled and admonished biblical literacy and adherence to the tenets of their faith. They also emphasized the virtues of duty and responsibility, of charity and compassion. The van Gogh children were taught to be respectful and reverent and to remain loyal to their family at all costs. The lessons learned in his parental home coursed like a strong undercurrent throughout Vincent's life. He was well aware how much his and his siblings' personalities had been shaped by having their roots in a different kind of family.[5] Beyond the boundaries of the parsonage, Vincent saw a different life and was affected by it too. His father took him at times to visit his parishioners in their low, dark, sod-covered cottages. Being a sensitive child, these visits left him feeling sad and downhearted. In one of his letters to his brother Theo, he wrote years later, "Even as a boy I sometimes looked up with endless sympathy and respect into a half-withered female face where it was written, as it were: life and reality have left its mark there."[6]

Vincent wrote to Theo that their father had once reassured him when he was feeling particularly downcast that "melancholy does not hurt, but makes us see things with a holier eye."[7] Already as a child Vincent was a real seer; he was always looking, observing, and contemplating. He would always look at life with a holier eye as exemplified by what he wrote to Theo: "There is something in Paris that is

more beautiful than the autumn and the churches, and those are the poor."[8] After leaving his parents' home, Vincent would find ways to live with people who were destitute, poor, and marginalized. A biographer wrote that Vincent looked at life with different eyes, eyes that involved the heart in the seeing. From the south of France a year before he died, Vincent wrote, "Could it not be the case that if one loves something, one sees it better and more truly than if one did not love it?"[9] Once he began to paint, Vincent worked hard at translating this different and holier perception of the world through the language of his art.

STEADFAST LIFELINES

At the age of sixteen, Vincent was sent away to learn the trade of art dealership in the firm of Goupil & Cie, where one of his uncles was a partner. Theo was the recipient of over 650 letters from Vincent that began during this time. Letters provided the only way to bridge miles of separation between family members and friends. The van Gogh family members relied on these tokens of personal closeness and were avid letter writers.

Vincent and Theo's exceptional relationship could only be revealed to its fullest extent through the legacy of their (mostly Vincent's) letters. Needing someone to share his exuberance, his depth of feelings, his sense of loneliness and rejection, Vincent bared his soul without censure to Theo. His skills as an expressive writer preceded the expressive artist he was to become. Vincent first painted with words. By describing the simple, ordinary happenings of his daily life, he lifted them into a more deliberate awareness. The ordinary became extraordinary; the familiar and commonplace became exceptional.

Theo's letters became steadfast lifelines that reached out to Vincent throughout his many trials and struggles, alleviating his often self-imposed isolation. This bond was not only the beginning of a most personal correspondence but also of a patronage without which there would never have been the artist Vincent van Gogh. Many of Vincent's

letters were about the monetary support he needed from his brother in order to continue painting. Many of Theo's letters contained that support. And over the years, Vincent wrote letters to Theo acknowledging that support.

Two years before his death, Vincent wrote these moving words to Theo from Arles, "Right now I don't yet think that my paintings are good enough based on the advantages I have received from you. But once they will be good enough, I assure you, that you will have created them just as much as I, and that it is the two of us who have made them together."[10]

Looking at *The Potato Eaters*, at Vincent's many painted wheat fields, and at *Starry Night*, we have to remember these are the creations of both Vincent and Theo.

A PASSION FOR LEARNING

After leaving the small town of his birth, Vincent began a nine-year odyssey through some of the largest cities in Europe—The Hague, Paris, and London—where the firm of Goupil & Cie had their branches. Life in these cities opened up a new world for this country boy. His habit of roaming through heaths and meadows now turned into endless forays through the hallowed halls of museums and myriad galleries. With insatiable curiosity and delight in discovering new sights and subjects, he began what was to be an enduring in-depth study of the life of artists and their work. The world of pictures was not foreign to Vincent. Even though he grew up quite isolated from the cultural mainstream of famous art, he was nevertheless well acquainted with the fact that images conveyed visual stories and messages. In a home where pictures were used to teach moral and ethical lessons, where the biblical parables evoked agrarian scenes, Vincent had become familiar with the emphasis placed on the interpretations of the visual language.

Paintings provided a didactic encounter between image, artists, and viewer. The more culturally informed one was, the more one had read

the Bible and other classic texts, the better one could become involved with associating the pictures with their storied messages. Vincent also began a lifelong habit of collecting art prints, which he pinned on the walls anywhere he stayed a while. He often added his own text and interpretations in bold letters on the margins of these prints. And everything he saw, read, heard, and felt was described in long-winded and enthusiastic letters to Theo.

He gravitated toward the paintings of the Dutch landscape painters who portrayed the world of nature he loved and missed while living in the cities. During times of homesickness for his beloved Brabant, he derived a great deal of consolation by looking at paintings of low-hanging clouds over wheat fields, of straight country lanes lined with pollard willows and birches, or of the distant horizon with the silhouetted spire of a village church. He also felt drawn to the paintings of the French social realists whose subjects were taken from among the common people.

When he was working in London, Vincent saw the illustrations of the urban poor that were published in the periodical *The Graphic*. This London weekly newspaper was dedicated in its founding principle to issues of social reform. On his long walks through the streets of London, Vincent could witness the poverty and dismal conditions of the men, women, and children of the almshouses just as they were portrayed in *The Graphic*. Gradually, the art prints hanging on the overcrowded walls

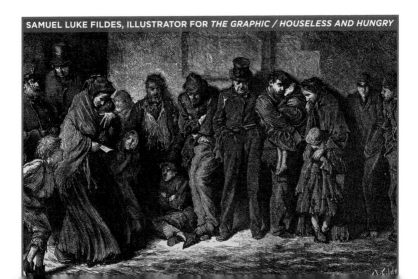

SAMUEL LUKE FILDES, ILLUSTRATOR FOR *THE GRAPHIC / HOUSELESS AND HUNGRY*

of the Goupil galleries with subjects of battle scenes of bygone eras and of exotic places lost almost all appeal for Vincent. He felt that this art had no relevance to present-day issues and was far removed from the flow of life taking place in the streets.

Since Vincent had learned that images could describe the splendor of the natural world as well as teach and convey messages of ethical and moral values, he believed art had to have such a purpose. Art had to be imbued with meaning that could be read and interpreted. Such images would leave a lasting impression and often say more than the printed word. Therefore, Vincent felt that it was the artist's duty to use the visual language for subjects that were relevant to life. Art had the potential to enlighten, to communicate, and, as in the example of the illustrations in *The Graphic*, to initiate the reforms needed in society.

RELIGION AS A REFUGE

While Vincent was at the London branch of Goupil & Cie, he met and fell in love with his landlord's daughter. Unfortunately, his ardent feelings were rebuked, which sent him spiraling into a depression. Along with his ever-present homesickness and his suffering from this hurtful rejection came the mounting conflict about the career path his family had chosen for him. To assuage his melancholy and loneliness he took refuge in familiar territory, reading the Bible. He also attended church services and came under the spell of the charismatic preacher Charles Spurgeon, who drew large crowds to his worship services in London. In the Bible as well as in books of religious nature, Vincent hoped to find solace and meaning for his misery. His increasing dissatisfaction with selling art and his present preoccupation with religious writings caused him to neglect his work in the galleries. He was transferred to Paris from London, where it was hoped the change in scenery would revive his zeal and focus in learning the trade. Paris was aflame with new ideas about art, but Vincent paid little heed. He remained rooted in literary works by religious leaders and philosophers.

He read books by Thomas Carlyle, Ernest Renan, and Thomas à Kempis. Many of the ideals and philosophies expressed therein sunk deep into Vincent's soul. He was profoundly influenced by Renan's description of Jesus as a historic figure whose spirituality led him to a life of compassion. Thomas à Kempis's admonition to renounce all personal desire and reach for fulfillment through selfless acts of care set Vincent on a trajectory that would eventually lead him to actually renounce all personal desire and live solely for his art. Vincent spent countless hours transcribing Scriptures, summarizing sermons, and copying hymns for Theo. And he spent every leisure moment studying the Bible with a young colleague in his small Paris apartment. He focused on collecting prints featuring religious themes, adding Scripture passages and quotes in the margins.

DISMISSAL AND NEW BEGINNINGS

As he was no longer fulfilling his responsibilities as art dealer apprentice, Vincent was finally dismissed from the Goupil galleries. He had no other recourse but to return home. There he had to endure the shame his failure had brought on himself and his family. Other attempts at working different jobs did not last long. All this put a large strain on Vincent's parents. When he began talking about wanting to follow in the footsteps of his father and become a pastor, a tenuous hopefulness was awakened. With the blessing of his parents and renewed enthusiasm, Vincent left for Amsterdam, where he began preparing himself for the entrance examinations required to enroll in theological studies at the university. He balked however at studying the required ancient languages. All he wanted to do was minister to the poor and the destitute. He endured another failure when he abandoned his preparatory studies. He returned to a thought he had had years earlier while living in London when he considered doing missionary work. This, he felt, could now become an alternative to the vocation of an ordained pastor. In his letters to Theo from Amsterdam,

he sounded optimistic again, despite yet another failed attempt at following through with a vocational plan.

> Happy is he who has faith in God, for he shall, although not without struggle and sorrow and life's difficulties, overcome in the end. One cannot do better than, amidst everything in all circumstances, in all places and at all times, to hold fast to the thought of God and to strive to learn more of Him; one can do this through the Bible as well as through all other things.
>
> It is good to go on believing that everything is full of wonder, more so than one can comprehend, for that is the truth; it is good to remain sensitive and lowly and meek in heart, even though one has to hide that feeling sometimes, because that is often necessary; it is good to be very learned about the things that are hidden from the wise and the educated of the world but are revealed instinctively to the poor and simple, to women and babes.
>
> For what can one learn that is better than what God has put by nature into every human soul, namely that which in the depths of every soul lives and loves, hopes and believes, unless it is wantonly destroyed?[11]

His faith gave him the assurance that he would eventually succeed in following a worthwhile and purposeful path. He found a school that trained missionaries in Laeken, Belgium, and enlisted there.

MISSIONARY IN TRAINING

With a renewed drive Vincent began his training at the school for evangelist missionaries in Belgium. Vincent was an exasperating pupil; his insubordinate nature soon led to another failure to complete what he had set out to do. He did not succeed going beyond a three-months training period. But even without adequate training and without being given a missionary assignment, he was determined to serve the poor and believed that whoever wants to preach the gospel must have it in his

own heart first. "Oh! that I find it, for it is only the word spoken in sim-
plicity and from the abundance of the heart that can bring forth fruit."[12]

Vincent had heard of the poverty-stricken mining district in northern
Belgium called the Borinage. This is where he felt he could do the most
good. During his times of trials and tribulations Vincent kept writing to
Theo not only to assuage his brother's worries but also to encourage
himself and to grapple with his own difficulties and to strengthen his
own resolve.

> You surely know that one of the roots or fundamental truths, not
> only of the Gospel but of the entire Bible, is "the light that dawns
> in the darkness." "Through darkness to Light." Well then, who will
> most certainly need it, who will have ears to hear it? Experience
> has taught that those who work in darkness, in the heart of the
> earth like the miners in the black coal-mines, among others, are
> very moved by the message of the gospel and also believe it.[13]

Without the initial backing from the Belgian Mission School com-
mittee but with a recommendation to present himself to a local pastor,
Vincent arrived in the small mining town of Pâturages in the Borinage.
Looking the part of a missionary in a respectable suit of clothes, he felt
confident. The well-built young man with his polite and proper Dutch
manners also impressed the local pastor. Being capable of expressing
himself well in French, Vincent was given a small group of Protestant
miners and began to lead religious services. He also taught Bible
lessons. After hearing about these initial efforts at missionary work, the
superiors at the missionary school agreed to give him another chance
and to support and supervise him for a six-month trial period.

IN SOLIDARITY WITH THOSE WHO
WALK IN DARKNESS

The conditions Vincent encountered in the Borinage were dismal. The
mining families lived in utter poverty. Their small, dark cottages offered

little comfort and often had no access to running water. Twenty-three thousand men and women worked in the mines, joined by almost eight thousand children and teenagers. The shifts averaged twelve hours and the mineworkers rarely saw sunlight. The sanitary conditions in the mines were subhuman. The air in the shafts and galleries was putrid and hot, and little was done to ensure the miners' safety. Medical and social aid was nonexistent for the many victims of mining accidents and explosions. The population was ravaged by many different kinds of ailments, including malnutrition, respiratory diseases, typhoid fever, and tuberculosis. Alcoholism was rampant, causing further hardship that threatened the fragile fabric of family life. Children, because they had little or no access to formal schooling, were left no alternatives but to follow their fathers into the mines when they became strong enough to work, thus perpetuating the cycle of poverty and destitution.[14] Vincent had truly come to a people who literally walked in darkness.

A worship space of sorts was set up in what used to be a small dance hall in one of the row houses of a little town called Wasmes. Here Vincent, standing in front of miners and their families, preached his sermons. As he gazed into the coal-stained and emaciated faces of the men, women, and children before him, he recognized the same expressions of privation and hopelessness he had seen so many times before in the dimly lit huts of the Brabant peasants and in the poor quarters of the cities. And it began to dawn on him that preaching Bible Scriptures and sermons from behind his makeshift pulpit was not effective enough to bring the comfort and light promised by the Bible.

In order to discover what he could do to alleviate the suffering of the members of the small congregation gathered before him, he had to personally experience their desolation; he had to literally walk in their worn-out wooden clogs. Only then could he actually live, rather than preach, the meaning of the gospel message and "do unto others, as you would have others do unto you." This biblical maxim called for action and a more conscious effort to understand others. He resolved to enter

into a deliberate solidarity with them in order to share their plight. Vincent felt that love and friendship were not just feelings but also, and always, called for positive action that required hard work and exertion at times. Such action could combat the fatigue and powerlessness one often felt standing before situations of poverty and misery. What one had to keep doing was to love sincerely and act in good faith.

The manner and focus of Vincent's ministry changed. He increasingly visited the miners in their homes. Wherever he discovered empty cupboards and hungry children, he shared his own meager rations of food. Despite being worn out himself, he often sat for hours at the bedside of sick miners to pray with them and to give some relief to their wives. He used his last shirt to dress the wounds of a miner who had been seriously hurt in the mine and who had been given up for lost. Thanks to Vincent's selfless and devoted attention, the man was nursed back to health. Vincent tore up his bed linens to make bandages for miners who had been injured in firedamp explosions. After being reprimanded for destroying his sheets, he told the wife of the baker he boarded with, "Oh, Esther, the good Samaritan did more than that! Why not apply in life what one admires in the pages of the Bible?"[15]

He went to visit a sick miner who wanted nothing to do with the young missionary, the *"macheux d'capelets"* (rosary chewer), as he derisively called Vincent. But Vincent persisted in his visitations and in giving him care, and eventually even succeeded in having the man listen to the gospel stories. Besides tearing up his last shirt and his sheets for bandages, he went even further and abandoned all privileges granted to him as a missionary. He left the relative comforts of the cottage of his host family and moved to a lowly hovel with a miserable pallet of straw to sleep on. What was good enough for the poorest of the miners and their families was good enough for him. When his hostess tried to prevent him from leaving, she remembered him turning to her and saying, "Esther, one should do like the good God; from time to time one should go and live among His own."[16]

Vincent no longer wanted to be regarded as the one who came from the safe place of religious authority and higher social rank but as one who participated in the same human condition.

HUMAN RIGHTS ACTIVIST

Vincent followed wholeheartedly the ideals he gleaned from Thomas à Kempis's writing, namely, to practice self-denial and to devote every living moment to those less fortunate than himself. Vincent aimed, therefore, to live among the people, as he understood Jesus to have done. He was practicing his faith completely freed from the rules imposed by religious institutions. Nothing distracted him from his self-sacrifice. This utter disregard for his well-being surprised the miners, who were more accustomed to missionaries preaching at them from a safe distance. In those years and in that place, the devotion and solidarity shown by someone who was not of the same social class was very unusual and almost incomprehensible. At the invitation of one of the miners, Vincent even descended the vertical shaft of one of the mines into the dismal pit, one of the "pits of hell" as he called them. Spending six hours in a mine seven hundred meters under the earth's surface gave him the chance to explore the world of the miners firsthand. Apparently, Vincent, upon seeing the pitiful situation the miners had to work in, exclaimed, "How can they treat God's creatures like this?"[17]

Thanks to this experience, Vincent eventually became a spokesperson for negotiations with the mine bosses of the Borinage to change the harrowing conditions in the pits. He confronted the superiors as an advocate for the underpaid and poorly treated workers. In a real sense, Vincent became the champion for the human rights of the miners during a time when these poor had no rights at all. When an uprising and strike broke out, Vincent prevented the miners from setting fire to the mine, telling them not to be "unworthy men, for brutality destroys everything that is good in man."[18] According to witness accounts, Vincent was the only man the enraged miners would listen to, ensuring

that neither side violated each other's sense of self-worth and dignity. In the Borinage, Vincent had to rely on his own resources. Through the bonds he created with the miners, he succeeded in gaining self-esteem and self-worth and purpose—albeit at the expense of his own health and strength.

VINCENT'S OWN PIT OF HELL

When a delegation of the Belgian Evangelization Committee was sent to assess Vincent's mission work, they were appalled at finding their young representative indistinguishable from the miners he had come to serve. This missionary in training, in their judgment, was too radical in his service, and therefore could not remain a member of the respectable Belgian Missionary Society. Vincent was dismissed as unfit for missionary work.

Now with few options and no prospects for employment, Vincent decided to return to the Borinage after a brief visit with his parents. He moved to the town of Cuesmes, where he found refuge with a miner's family. He was offered space in an already-crowded bedroom with the miner's children out of gratitude for his role in caring for the miner's son who had been stricken with typhus. Vincent was weak due to the deprivations he had suffered. He wanted to continue his ministry but lacked sufficient strength. He felt discouraged, for he had not only been abandoned by the religious establishment but also was judged to be idle and lazy by his family. Even his brother Theo was questioning Vincent's motivation to stay in the Borinage without any plans for self-sustaining work.

Feeling misjudged by his brother, Vincent didn't correspond with him for eight months. This long period of silence was his most lonely and desperate time. He was paralyzed by his misery; poverty and deprivation had disheartened and *imprisoned* him. During this time of darkness within his own "pit of hell," Vincent began to respond to an inner spark that would ignite into his true vocation.

SORROWFUL YET ALWAYS REJOICING

In one of his earlier letters written from the Borinage, Vincent had shared with Theo that "in the dark atmosphere of suffering in the Borinage there is always something that absorbs me."[19] He wrote about the miners being thin and pale from fever and the women looking faded and worn. As always, such human struggle filled him with empathy and drew him into their suffering and fueled his faith. "You see, it always strikes me and it is something remarkable, when we see the image of unspeakable and indescribable abandonment—of loneliness—of poverty and misery, the extreme end of things—the thought of God arises in our mind. At least this is the case with me."[20]

He was not only moved by the people but also by his surroundings and described them as being blackened from smoke, with thorny hedges, dunghills, and dumps lining the streets. His words evoke a mood of bleakness and certainly nothing so enticing that it should be captured in a painting. And yet here Vincent proved that art was never far from his mind, for he was able to discover pictures worth painting in all the dreary subjects around him. Despite his loneliness and hardship, he was still capable of seeing something beautiful within the soot-tainted environment; there was always something that could ignite his interest. He wrote to Theo, "You will find all kinds of things here in nature and in its peculiar character that will attract you—there is so much that is picturesque in this region."[21]

Only someone intent on seeing the light in the darkness, on seeing beauty in what most would deem not worthy of attention, would be able to describe any aspect of the Borinage as "picturesque." Seeing a weak sun struggling to shine through the coal vapors in the blackened countryside reminded Vincent of paintings that through the subtle juxtaposition of light and shade—the chiaroscuro effect—had elicited a mood of melancholy. Vincent responded to the vistas he saw around him with a heightened sense of enthusiasm when they reminded him of similar scenes painted on canvas. So much of what he noticed on his lonely walks brought back memories of things that

had previously moved him or impressed him and about which he wrote passionately to Theo.

Before he had left for the Borinage, Vincent had predicted that he would never feel completely lost or lonely as long as he could remember the images of art works he loved. Thus, he continued to derive consolation and inspiration not only from the art he remembered but also from the books he read, and above all, from his love of nature, albeit at the present time a nature covered with charcoal dust and littered with slag heaps. For him light, even if very dimly, did shine in the darkness of the Borinage. He expressed this sentiment often by quoting one of his favorite Bible verses: being forever "sorrowful, yet always rejoicing" (2 Corinthians 6:10 RSV).

SKETCHING THE ASPECT OF THINGS

Ever since Vincent had begun writing letters, he would add little drawings on the margins. Writing to Theo from Laeken while still at the missionary training school, Vincent had added a sketch of the pub where he had initially met the miners from the Borinage and admitted that "I should like to start making rough sketches of one or the other of the many things one meets along way, but the considering that it would actually not take me very far and that it would most likely keep me from my real work, it is better I do not begin."[22]

But now in the miner's cramped hut, cut off from the world of religious institutions, familial expectations, and cultural constraints, Vincent was undergoing a transformation. During the months of his selfless devotion to the miners' well-being, and during his own descent into abject poverty, something had begun to stir within him. The concern that sketching would keep him from his real work was gradually displaced by surrendering to his urge of making rough sketches. In the evenings, sitting tired and hungry in the cramped bedroom he shared with the miner family's children, he had begun drawing by the light of a smoking oil lamp. "I stay up often drawing far into the night

so that I can hold onto some souvenirs and strengthen my thoughts that are involuntarily awakened by the aspect of things seen here."[23]

The act of drawing awakened his latent passion. Using a piece of charcoal and scraps of paper, his hand began to intuitively sketch. The satisfaction he felt in these early attempts encouraged him and strengthened his willpower to endure.

A MOLTING TIME

Vincent penned a most moving letter to Theo explaining the discovery of a new *raison d'être*. He used wonderfully descriptive metaphors for the liberation of an imprisoned soul.

> What molting is for birds, when they change their feathers, that is what adversity or misfortune, the difficult times, are for us human beings. One can stay in it—in that time of molting—or one can also emerge from it as if renewed; but anyhow it must not be done in public, it is not at all amusing, it is not gay, therefore, the best thing to do is to go into hiding. Well, so be it.[24]

Emerging from his "molting time," Vincent still kept his resolve to do his "real work" among the poor and the destitute, as well as that of spreading the gospel message. But he had to find a way to connect his ministry with his desire to take up his pencil. He looked to the one artist

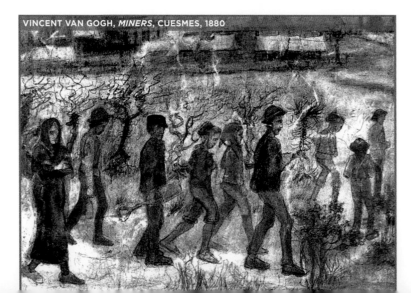

VINCENT VAN GOGH, *MINERS*, CUESMES, 1880

who he felt had succeeded in bringing the biblical parables to life in his paintings so that they were universally understood. He wrote to Theo that "there is something of Rembrandt in the Gospels or something of the Gospels in Rembrandt."[25] Through his own experiences of contemplating art works, Vincent knew that visual images could be revelatory, evoke feelings, console, and comfort. Rembrandt had been the one artist whose art unfailingly did this for Vincent. Rembrandt is "so deeply into the realm of the mysterious that he says things for which there are no words in any language."[26] The sketch he included in a letter written in August 1880 was still a crude drawing, but with it Vincent had wordlessly portrayed the miners' hard and destitute life as they trudged to the pit through the early morning snow.

Explaining his aim with drawings such as the miners' sketch, he wrote, "The miners and the weavers are somewhat of a race apart from other workmen and artisans and I have a great sympathy for them and would count myself happy if one day I could draw them, so that these unpublished, or as yet almost unpublished types, could be brought into greater awareness."[27]

And thinking about artists like Rembrandt who succeeded in expressing true sentiment and human soul in their paintings, Vincent added, that he hoped that someday he could prove to Theo that he was an artist too. "I don't know in advance what I am capable of, however I do truly hope to make some sketches in which there could be something human in them."[28]

■　■　■

Henri hoped that through discovering Vincent, we would find in him a guide and companion in living a compassionate life, even though Vincent was so often lost himself, struggling, looking for support, love, and peace. But Vincent seemed to say to us too, "It is all here: immerse yourself in living your life to the fullest." Henri and Vincent both encouraged this. The following stories are about our full immersion into the fabric of parish life.

Learning to Live in Solidarity

I spent my earliest childhood in Amsterdam and moved to Switzerland when I was eight. I grew up in a small Swiss town and eventually went to high school and had my first job in the city of Zürich. It is remarkable that a few years after the end of World War II, I saw no evidence of the great suffering that had taken place all over Europe just beyond the Swiss borders.

Only when we made visits to my grandmother in Prague did I notice hardships and deprivation. I saw people begging for alms in the streets of some of the largest cities in Europe. Unlike Vincent, I never gave my last shirt or shared my meals.

A chance encounter with a handsome young American on a tram heading to the main train station in Zürich eventually led to the experience of living among the poor and sharing their hardships. On this particular day, Steve was on the same tram I took daily to return home from work in order to continue my studies in the afternoon. Little did I know that the true destination of this first meeting would soon lead me to another continent as his bride and into adventures and places that I had never imagined were part of my future. I emigrated to the United States in 1974, and Steve and I settled into our first home in Bangor, Maine, where Steve was hoping to finish his undergraduate degree. After the spring semester, we spent several weeks in northern Vermont at his family's summer cabin. I fell in love with Vermont, and

both of us longed to remain in this state rather than return to Bangor in the fall. Another chance meeting, this time at the general store, brought us the opportunity we would not have dreamed possible. Steve was asked to become the student pastor of two churches in that area. And before the summer was over, he had officially become the local pastor of two small village churches in Vermont.

I began my married life as a minister's wife in the rural hills of northern Vermont, far away from the cosmopolitan atmosphere of Zürich.

SOLIDARITY IN THE GREEN MOUNTAINS

As soon as Steve could, he enrolled at the local state college to continue his undergraduate studies. Not long afterwards, I found a part-time position at the same college.

Steve's role in this new life of ministry was defined by sermon writing and parish visits. But as he soon discovered, that was the tip of the iceberg. As for me, I had no role model or script to follow. Not knowing what was expected of me meant that I did what I expected of myself, namely, anything I saw that needed doing. Preparing the sanctuary for worship on Sunday mornings with the wildflowers picked in the fields was a creative outlet for me. I enjoyed decorating the covers of the church bulletin with some of my drawings and picking out poems to read weekly in my role as liturgist. The most important and challenging of all my responsibilities became that of co-youth group leader and that of simply reaching out—visiting the old and the sick and the needy in their homes. These tasks taught me the most.

We were aware that we lacked understanding and maturity to deal with the demands and situations that arose in the two parishes—we were both only twenty-four years old. We often felt as if we were drifting without a rudder in an ocean of human needs. But the needs became our call, and we were on call 24-7. We responded as best we could to the people we had come to serve—not just the few members of the two churches but also the people of the surrounding communities. The

asbestos mines had just closed and many men were out of work. Many families were on welfare, living in trailers or dilapidated homes, lacking material goods and comfort.

It was a foreign world to me, and I had trouble figuring out how to navigate the circumstances and traditions of this rural life; I definitely experienced Vincent's metaphor of having to work myself through the invisible "iron wall" that stood between what I felt and what I could or wanted to do. But breaking down that wall didn't take long, for as our paths led us to the men, women, and children around us, relationships began to form. The solidarity we eventually shared with the people helped us gain the understanding and maturity we lacked.

ENTERING HOMES

In the beginning I had to overcome my anxiety about calling on people I didn't know. I felt that I was intruding. I was also shocked at some of the unlivable conditions I encountered in the outlying areas of the two parishes where ramshackle trailers often lacked adequate heat and had no running water. I remember entering one place where dishes were piled high in a sink covered in grime. Half-filled food jars and tin cans littered every available surface, including a round table where several people were gathered. The women were smoking, and when they spoke, I noticed their rotting teeth.

Despite my uneasiness, I was touched by their hospitality toward a stranger. They eyed me curiously but were friendly and continued smoking and talking to one another. How would I ever learn to fit in and relate? I had nothing in common with these people, or so I thought. At that time all I could think of, beside washing my hands, was to help clean that place up. Such actions I now know would have led to a conditional solidarity and not one Henri highlighted in the example of Vincent's life.

COMMUNITY RALLYING

Almost immediately after Steve began his ministry, there was a death in the community, and he had to prepare his first funeral service. The proprietor of one of three lumber mills in the area had died, which brought many people together into the small sanctuary of one of our churches. The whole community was drawn to this loss, and I saw for the first time the cohesion of an otherwise widely spread-out village. I was to experience how rural communities dealt with death or marriage or disaster in their midst many times. Such events invariably involved the pastor and, more often than not, his wife too. Upon entering the church for our first funeral, I noticed that many of the congregants must have come directly from their farms or the lumber mills, still wearing their work-worn clothes and mud-spattered boots. The owner of one of the competing lumber mills sat in the back pew, covered in sawdust and holding his spittoon on his knees.

Memorial services, weddings, and a home lost through floods or fires were times that called for community solidarity, not only in funeral homes and churches but also in general stores where a jar or cigar box would appear on the counter with the name of the persons in need. Money accumulated for a period of time, giving everyone a chance to be involved, even peripherally, in each other's well-being.

As I was shown how to assimilate into the life of the village, my attitudes changed. I became less uneasy, judged less, and cared more. I was beginning to understand the folks' ways and paid greater attention to our commonalities rather than to what set us apart. Vincent expressed these same sentiments while living among the miners in the Borinage. "With the miners one has to have the nature and character of a miner, and no pretentions, haughtiness or a tendency to lord over them, otherwise one cannot get along with them and will never win their trust."[1]

I knew I was gaining the confidence and trust of the women when I was included in their circle and initiated into cooking the monthly church dinners. And I was elated when one of the women, Rita, my first

true friend in the northeast kingdom, came by one day with a bag of her homegrown potatoes and an invitation to join her quilting group.

LESSONS LEARNED

The folks we had come to as a young minister's couple will never know how much they had a hand in teaching us how to become compassionate. Despite their own struggles and life challenges, they had become sensitive to our needs and weaknesses and encouraged us in our efforts to minister to them. They welcomed us into their homes and lives, where we could recognize our common bonds regardless of our different backgrounds and upbringing. I realized I could only enter into solidarity with them once I was willing to let go of my preconceived notions and my fear of the unknown. Once I had emptied myself enough, I could be filled with a larger view of life. Most of the time, Steve and I did not have the answers or the advice we imagined was expected of us. But we learned how to listen and be present to the other. This, we found, had more value than giving advice.

The more we shared our life genuinely with the people around us, the more we gained insights into ways of caring. We came to understand that the answers expected of us were often fulfilled by being present and sharing the hardships. Typing sermons and preaching on Sunday mornings remained a fraction of parish life during those years. A stand taken in unity with the misunderstood (on both sides of an argument), a hand held while listening, a hug given, a cup of coffee poured, a casserole offered, a prayer shared—these were gestures in joint solidarity that comprised our true ministry as we participated in bringing down walls of separation.

Many of us never experience the total nakedness, loneliness, and confrontation with the essence of life as Vincent had in the Borinage. But in our moments of suffering and doubting in our early years of ministry, we did come closer to that reality, to the roots of our existence, and to the understanding of our potential and purpose.

Looking back on those three years in our rural parishes, I now see that they were like a time of molting for us, a time of struggle and transformation from which we emerged with new light and vigor. Learning about Vincent's time in the Borinage affirmed that in order to see that light we had to first experience a place of darkness where we could confront our deepest selves. Just as I would find in the example of Vincent, we had to be willing to let go of our comforts, take risks, and enter into that lonely place in order to have life-changing revelations. From such a place of solidarity we could rise with new knowledge and understanding about how we should live.

Vincent, rejected by his parents, by friends, by institutions, and by society at large during his time in the Borinage, could eventually discern what his true nature called him to be. This allowed him to follow his own conscience. After his Borinage experience, he no longer complied with social rules that made no sense to him and were devoid of any real meaning and value. Simplicity, meekness of mind, love for many things, sense of duty—Vincent tied many aspects of life together into his new sense of being.

Our three-year journey in northern Vermont became the most fertile ground from which our future years of ministry, our new sense of being, could grow. Steve's graduation from the local state college marked the time for us to make plans to move on. But we had to first overcome the roadblock in the form of the rejection letter that had been thrown into the fruit bowl on our kitchen table . . .

Part Two

Consolation

The compassionate
manifest their consolation
by feeling deeply the wounds of life.

HENRI NOUWEN

I couldn't draw Sorrow
if I didn't feel it myself.

VINCENT VAN GOGH

4 | HENRI

Vincent Feels Deeply the Wounds of Life

We were by now partway through our course with Henri, and we had yet to meet Vincent the artist. Henri had wanted us to spend a considerable amount of time with Vincent in the cold, dark place of the Borinage where Vincent committed to his deep solidarity with a suffering humanity. In the Borinage there had been nothing to shield Vincent from the nakedness of his poverty and starkness of his misery, except his own soul. In the direct confrontations with the plight of the miners and having nothing left to give but himself, his solidarity helped him to discover his own inner spark; it transformed him. And within his inner being he realized what he was meant to do and more importantly what it meant to be Vincent.

Enriched with the understanding that he was an integral part of a suffering humanity, he realized that his personal call to a life of compassion would be fulfilled as an artist. And Vincent discovered that what had nurtured him since childhood—the biblical parables, art, stories, and the closeness to nature—would guide him in his true vocation. In the future he would attempt to alleviate the basic human needs for comfort and hope with the powerful images of his art

During the time we spent in the Borinage, Henri enabled us to witness how Vincent sought to live his faith by doing what he believed Jesus would have done. This was a Vincent most museumgoers would never encounter. Henri gave us the experience of agonizing with

Vincent in his struggle to find his vocation as the artist we know today. When religious authorities rejected Vincent, we asked ourselves silently if it was better to keep the status quo, adhere to rules, and play a role, rather than suffer the consequences of being authentically human. Henri, meanwhile, continued taking us on our journey with Vincent, thereby offering us an example of what it meant to be the latter and live with integrity.

BECOMING PRESENT

Henri stressed that to become compassionate people, we had to recognize and admit "our intimate solidarity with the human condition."[1] We had to give up our desire to be different, exceptional, or better than the others in order to become a consoling presence.

> Consolation demands that we be *cum solus* with [alone with] the lonely other, and with him or her exactly there where he or she is lonely and where he or she hurts and nowhere else. Consolation is . . . not the avoidance of pain, but, paradoxically, the deepening of a pain to a level where it can be shared.[2]

This was a hard concept to grasp and Henri knew that. And here we could see why Henri had chosen Vincent van Gogh as his case study. Through Vincent's story, through the parable of his life, we were to come closer to an understanding of what it meant to be a consoling presence.

After leaving the Borinage, Vincent consciously made the choice to stay close to the suffering of others. He kept going to unpopular places to draw and paint people who most others did not consider worth paying attention to, reminding us that this was living according to the example of Jesus. Emerging from his isolation and time of transformation in the Borinage, Vincent moved back with his parents, who now lived in the small Brabant parish of Etten. He was not free from worries or from parental expectations. He still had no guarantee of a gainful occupation and was therefore still dependent on familial support and very vulnerable. Yet he had attained the freedom of self-determination—

the relief of giving in to his vocation at last. Having a place to live for a while enabled Vincent to devote himself entirely to practicing the skills he needed in order to express graphically what he saw and felt. He was now given the chance "to struggle as hard as he wanted to in order to come in touch with the heart of life as he saw it in the poor of spirit," said Henri.[3] He lived close to the people he drew and felt their existence from within his own experience. This way he was able to see beyond the surface of poverty and depravity and connect with life on a more truthful and intimate basis.

Continuing on his path to unpopular places, when Vincent left Etten he moved to a poor district of The Hague, where he invited one of his models, Sien, to live with him. She was a poor, worn-out prostitute who had a young child and was pregnant with another. He cared for her and her child, and gave her a safe place to stay while she awaited the delivery of her second child.

Henri cited the example of the choices Vincent made in The Hague as the time when he not only shared in the pain and suffering of a destitute woman but also increased his own pain. Vincent was suffering from his own deteriorating health and from his lack of recognition and inability to sell his work. The commitment Vincent made to Sien would make him share what meager resources he had and therefore sacrifice his own comfort and well-being. Vincent endured his own suffering and Sien's destitution together with her, and this was, according to Henri, a most moving portrait of consolation.

Henri elaborated,

When we say to a suffering person, "don't cry" or "things will be better tomorrow" or "don't worry," we really try to move that person to a place where he or she is not. But to console means first of all to be with someone where it hurts. And that's not very easy because how can you be with someone who hurts if you don't want to be here with your own pain. And therefore we run away from the pain instead of deepening it. We want to avoid it and cover it up.[4]

Our culture prefers to deaden pain rather than deal with its reality. Henri urged against the avoidance of pain. He was rather warning people to be more human, and pain is part of that, just as is joy. Henri emphatically added, "To say that I too am in pain, that I too am part of that human condition, that's a very hard thing to say and to feel. And still that's what I think consolation is."[5]

Vincent installed himself in a studio that became, as he saw it, a shelter for the poor who came to model for him. Just like in the Borinage, he was so radical in his convictions that he not only came close to their misery but became a part of it. And as he had done in Etten, he struggled through hundreds of drawings of these models in order to reach the depth of their human condition—"the heart of life as he saw it in the poor of spirit," according to Henri. Being as poor as they were, he identified with their wounds of life and would rather go without a meal himself than not pay them a modest few coins for their modeling. Bringing them into his apartment satisfied the longing he had always felt to be of use and to help forsaken creatures: "When one lives with others and is bound by a feeling of affection, then one is conscious of a reason for being, that one might not be entirely worthless and superfluous but perhaps is good for one thing or another."[6]

One of the images Henri wanted us to spend a considerable amount of time with was a drawing of Sien called *Sorrow*. This simple drawing expresses a universally understood and deeply felt emotion. Vincent, as expressed to Theo in one of his letters, could not have created this expressive image if he hadn't felt this kind of sorrow himself. He had spent time *cum solus* with Sien and her children and without pretense entered into their pain. By feeling the wounds of her life, he understood her predicament and became a consoling presence. This straightforward sketch epitomized his ability to feel deeply the wounds of another human being. Accepting and even welcoming the risk of his own discomfort and alienation from his family, he wrote to Theo: If "for a moment I may feel rising within me the desire for a care-free life, for

success—each time I go fondly back to the trouble, the cares, to a difficult life—and think, it is better this way, I learn more from it; it does not debase me. It is not on this road one perishes."[7]

On this level of existence there was nothing hypocritical, artificial, or superficial. There was nothing false in the struggle to survive. Drawings based on such circumstances would be honest descriptions of a slice of reality. Such images could lead to the recognition and admittance of a shared human condition and reciprocal consoling relationships. To justify his relationship with Sien, Vincent added that living with her would make him a better artist and a better person, rather than if he had remained in the respectable social circle of his family. This then had become more significant to him than to aim at a sense of societal respectability.

Henri concluded his talks about consolation with these words,

No one wants to increase his or her own pain, but rather invite the hurting person to come to a place, our own place, where the pain is less. For going down into the deep pain of another is like jumping into a bottomless abyss—not knowing if or where one will land. To grasp another's pain means letting go of our own safety limb and falling down to an unknown place. In this place we maybe won't have the answers that will help or alleviate the pain or explain it. We have to be willing to admit, then and there, down in the pit, that we too are helpless and weak and powerless. And who wants to do that, or be there?[8]

Vincent did that and was there with Sien and the people of the almshouses and soup kitchens. And Henri added, "For most often, we won't have the answers." More importantly we would be a presence.

Vincent did not have the answers for Sien. But by treating her with tenderness and esteem, he believed he could change her own perception of herself. She had never known goodness, how then could she be good and lead a wholesome life?

I must also change so much in myself, so that in me she has an example of diligent work and patience, and that is damned difficult, brother, to behave in such a way that one can model behavior for someone; I often also fall short. I have to improve myself to become something better in order to awaken in her the desire to do the same.[9]

He was not acting in a superior way but exposed his own vulnerability to her. Writing to Theo, he assured him that they both needed each other.

We began to understand. Not only would we not have the answers, but also it was precisely when we stopped looking for answers that we could become an unconditional consoling presence. The paradox of not offering advice in a situation where the need of it was perceived was almost unfathomable, but Henri kept reassuring us that this was getting closer to the dynamics of compassion. When we were willing, through a shared vulnerability, to admit that we were not coming to the hurting person from a place of superiority but were on equal footing, then we could begin to console.

COMMUNION WITH *THE POTATO EATERS*

When Henri showed us the slide of *The Potato Eaters*, he invited us to share the intimacy of the potato peasants around their simple table by again taking more time to look. We gazed intensely at the expressions of those sitting around the table and found ourselves in a mysterious way connected to them. Henri further elaborated on this dark image by describing what he thought to be the significance of the lamp shedding its hazy light over the peasants around the table. Henri felt that this light shining in the darkness became Vincent's symbol of love. It was a light that shed some warmth and brightness and consoled the peasants in their somber and lonely existence, a loneliness Vincent himself intermittently suffered from throughout his life. Vincent was always drawn to the warmth of a light, whether it was seen shining from a dimly lit

lamp in a peasant's hut or spilling out from windows and illuminating a walk at night. Vincent always sought to find that ray of light in the darkest corners where his desire to draw the reality of life had brought him. He also sensed a light, what he felt to be "more soul," in the hearts of the men and women he met in those gloomy huts. Henri reiterated that it was in those darkest places where Vincent encountered the quality that eternally pointed to the all-present power of love that unites us all.

On the campus of Yale Divinity School, Henri invited students every week, regardless of their religious background, to gather in a circle and partake in the simple act of breaking bread together—the Eucharist. For Henri, as for Vincent, such an ordinary moment of sharing some food and drink around a common table was a sacred moment.

5 | VINCENT

The Art of Consolation

When Vincent started his missionary work, he was a healthy and idealistic young evangelist eager to preach sermons and teach Bible lessons. He could quote many biblical passages and was fervent in his desire to bring the gospel message to the people "who walked in darkness." But more than two years later he was hardly recognizable. Thin and pale, lacking the strength to do his missionary work, he languished in the dark cottage of the miner who had allowed him to share a room with his children. Once so ardent in his use of religious language, he now no longer infused his letters with Scripture passages and religious poems and quotes. Theo worried about the changes he sensed in his brother, and Vincent responded that he was basically still the same brother and friend, despite all that had taken place during his time with the miners.

> What has changed is that then [before coming to the Borinage] my life was less difficult and my future seemed less dark, but as to my inner self, as far as my way of seeing and thinking are concerned, they have not changed. However, if in fact there were a change, it is that now I think and I believe and I love more seriously what I already thought, believed and loved then.[1]

On the level of solidarity with the miners, deep down in his own pit of loneliness, Vincent had encountered the most basic force pervading human existence: love. He had gone down, literally and figuratively, into the depths of the mine and had metaphorically discovered there not

the black coal but the transformed piece of coal, the diamond. He had discovered the treasure that is buried within his own being.

In the loneliest, dismal moments during his arduous service among the miners, Vincent realized that there was something greater than himself all along—the divine and creative force of love. He had seen the manifestations of this life force that permeated all of creation. Vincent also felt deep down that despite the interrupted flow of his correspondence with Theo, his bond with his brother still existed and was based on a love that had been instilled in them by their parents, their faith, and their vows to remain close. And above all, Vincent himself still had the capacity to love. Despite the misjudgments and failures suffered in the past and the low place he was in at the moment, he was convinced that in order to continue on his path he had to make love his foundation. "In order to work and to become an artist, one needs love. At least someone who wants to express feeling in his work must first of all feel and live with his heart. . . . To live, work, and love are actually the same."[2]

Vincent no longer studied the Bible; he had internalized the gospel message and the Sermon on the Mount and still believed as strongly as ever that he wanted to live according to Jesus' example and words. He now looked to the tangible and inclusive ways of loving and living amid all of creation in order to grow in his faith. Alone in his misery he had come to understand that approaching everything with love would nurture the ground of his being. The love he felt for all creatures great and small had always quickened his spirit and intensified all experience, leading to a deeper awareness of the unknown—the Something on High. When he had nothing left but the ability to love, he realized that he had tapped into an inner source of a greater love and that remaining open to this love ensured his salvation. The words he wrote to Theo could essentially be called his new, all-inclusive creed.

Everything that is truly good and beautiful, of an inner, moral, spiritual, and sublime beauty, in human beings, I think that that comes from God.

But I always think that the best way of knowing God is to love many things. Love that friend, that person, that thing, whatever you like, you will be on the right path of knowing more thoroughly afterwards; that is what I say to myself. But you have to love with a high, with a serious and intimate sympathy, with a will, with intelligence; and you must always seek to know more thoroughly, better, and more. That is what leads to God; that leads to unshakeable faith.[3]

In living through his Borinage experience, his senses had become more fine-tuned. In the cold, dark place he had been stripped from all that society had imposed and heaped on him. Now he could rely unencumbered on his innate way of relating to the world. Through his deepened awareness of the loneliness and suffering of the other, he had found ways to respond to individual needs. In the future he wanted to create works of art that would touch people in comforting ways. He intended his paintings to bring glimpses of beauty and light to those who lived in darkness and desperation. This meant he would make the marginalized in society the subject and the focus of his work in order to give them respect and recognition. His art, he hoped, would be accessible to all and not depend on material wealth or social standing. Vincent was now determined to develop the "mysterious language" of Rembrandt that said things without the need for words in any language. And of course it would be an art that first of all was inspired by his personal experiences and his faith, his own relationships with the poor in spirit, with those who mourned, with the meek, with those who hungered and thirsted for justice, with the pure in heart, with the peacemakers, and with the persecuted.

Someone will have attended, for a short time only, a free course at the great university of misery, and will have paid attention to the things he sees with his eyes and hears with his ears, and will have reflected about it; he too, will finish by believing, and will

perhaps learn more about it than he could say. Try to understand what the great artists, the serious masters, say in their masterpieces; God will be found there. Someone has written or said it in a book, someone in a painting.[4]

Besides holding on to his ideals of living charitably and justly, he was aware that it would take a lot of hard work to master those skills needed to "say it in a painting." Vincent was continuing his struggle to penetrate that "iron wall" in order to say what he felt. Communicating meaningfully would now also depend on the mastery of his pen and brush.

Throughout those early years he had remained grounded and steeped in the world of images stored in his memories and seen in prints that adorned all the walls in the places he lived. He was already astute in the expressive vocabulary of art. Now he had to become skilled and fluent in using it. All the associations he had learned to make concerning images and their meanings would feed Vincent's art making.

PRACTICING A NEW LANGUAGE (ETTEN)

The Sower. Vincent began to practice drawing while still in the cramped room of the miner's home in Cuesmes. From the prints he had brought with him and that Theo had sent him, Vincent had enough examples of art to copy and learn from. Many of the prints were based on the art of Jean-François Millet. For years Vincent had felt drawn to his work because of the iconographic representations of the workers of the soil—the sowers, the reapers, and the gleaners. Vincent wrote that in Millet's paintings, art is sometimes above nature, for there is more soul in Millet's *Sower* than in an ordinary sower in the field.[5] The people populating Millet's canvasses were the ones Vincent had always felt a kinship with. He hoped to learn how to paint such characters too so he could pay homage to them and edify them in the eyes of the world.

The act of sowing embodied a message of hope and regeneration. It also brought to mind the biblical parables Vincent was so familiar with. With great zeal, commensurate with that which he had exhibited as a

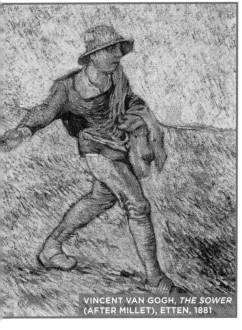

VINCENT VAN GOGH, *THE SOWER*
(AFTER MILLET), ETTEN, 1881

missionary, Vincent practiced sketching Millet's *Sower* over and over. Henri too was especially drawn to this image and its implied metaphors.

On the artist's path. It became increasingly difficult for Vincent to draw in the confining space of the small bedroom he shared in the miner's hut. He realized that if he wanted to make any progress he would have to leave the Borinage. Having gained experience at the "University of Misery," he finally brushed the charcoal dust off his feet and entered the artist's path. His first destination was Brussels, where he intended to attend the Académie Royale des Beaux-Arts in December 1880. He spent a few months there trying to prove to his family that he was serious about his new ambitions to become an artist. He was sketching furiously. He tried reconnecting with the art world through Theo's professional relationship, for by this time Theo was working for the Goupil galleries. But the financial support his father had promised him was not sufficient for his upkeep. By April 1881 Vincent had to return home to his parents, who had moved to a new parish in Etten, another small town in the Brabant province.

When their twenty-seven-year-old son arrived on their doorstep, Vincent's parents looked skeptically on his new plans for the future. Once back into rhythms of life in the parsonage, Vincent found it hard to conform to his parents' expectations and to abide by their social customs. In addition, to his parents' consternation, the parishioners looked askance at the pastor's son who they viewed as an eccentric

and a social misfit. Yet, paradoxically, Vincent felt he had found his place in the world. He had been in solidarity with those largely ignored by society and would continue to identify with them. He felt at home in the Brabant countryside, where on his long walks around Etten he encountered the peasants who lived in the scattered farms. With his aim to learn the artist skills and a renewed purpose, nothing could hold him back.

Drawing peasant life. Dressed like a common peasant and indistinguishable from them but for his sketching utensils in lieu of farming tools, he became a common sight around Etten. The folk living in the low, thatched cottages dotting the countryside became Vincent's models. Vincent drew them the way he saw them, at work with the sweat on their brow, the dust of the earth on their hands, and their muddy boots and patched work clothes. They questioned his disinterest in having them pose in their Sunday best but soon accepted his presence among them as they went about their daily chores, stopping now and then in a pose Vincent wanted to sketch.

Experiencing the restorative effect of his closeness to the rural life of the Brabant strengthened his resolve to become an interpreter of peasant life. In order to do so, he had to remain dedicated to the people he shared a common bond with, which he expressed in a letter to Theo written from The Hague a year later. His work was to be found in the heart of the people, where he had to keep close to the ground and delve deeply into life and make progress despite great cares and difficulties.[6]

> I have drawn five times over a man with a spade, a Digger in fact, in all kinds of poses, twice a sower . . . and finally an old, sick farmer sitting on a chair by the hearth, with his head in his hands and his elbows on his knees. . . . I have to now continually draw diggers, sowers, plowers, men and women. I have to observe and draw everything that belongs to peasant life. Just like many others have done, and are doing now. I no longer stand so helpless before nature as I used to.[7]

Observing and sketching the peasants allowed him to participate in their hardworking lives. He furthermore saw their struggles mirrored in the natural forms of the contorted tree trunks and twisted roots, in the changing seasons, and in the daily moods of the fluctuating weather. Drawing directly from life, his vision and feelings influenced his hand, which held the pencil that moved swiftly across his paper. Looking at the lines he had drawn made him reexamine the scene before him again and again, resulting in a continuous interaction between artist, the subject being observed, and the emerging drawing. This cyclical movement sharpened Vincent's perception, his awareness and insight, and enabled him to respond with ever-greater intensity and passion to his surroundings. He exclaimed to Theo, "Now I look at things with a different eye than I did during the time when I was not drawing yet."[8] All that Vincent would capture on his paper and canvas for the next nine years he saw with a different eye.

A SHELTER FOR THE CITY'S POOR (THE HAGUE)

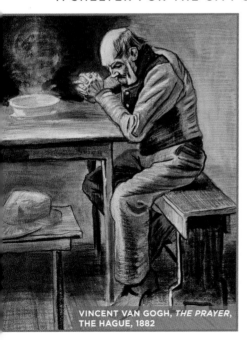

VINCENT VAN GOGH, *THE PRAYER*, THE HAGUE, 1882

An artist's studio. After eight months in his parents' home where disagreements with his father escalated and became unbearable, it was time for Vincent to move on again. On December 25, 1881, Vincent was in effect asked to leave the parsonage after a particularly intense argument with his father. Again on the road and homeless, Vincent set out for The Hague, hoping to find support there from an artist relative. With a promised allowance from Theo, who had fully taken over the responsibility for his brother's financial support, Vincent

stayed in The Hague for the next two years. He found a small apartment in a run-down section of town where he installed his studio. Just like in Etten, he set out looking for figures to paint and found them in the impoverished men and women of the almshouses and soup kitchens. As always, their simplicity and resignation to their lot in life moved him. He brought some of the destitute men and women into his studio, offering them shelter, some food, and a few coins for posing as models.

Feeling deeply the wounds of life. Vincent opened his home for a number of poor people who came to model for him. But he was particularly moved by the predicament of Sien, a prostitute. She was needy, pregnant, and ill. It wasn't so much erotic love that attracted Vincent to Sien as it was her misery and her privation.

> When I met this woman, she caught my attention because she looked ill. I let her use the baths and as many fortifying remedies as I could afford, she's become much healthier. I went with her to Leiden, where there's a maternity hospital for the confinement of women. . . . It seems to me that any man who is as valuable as the leather his shoes are made of would have done the same in such a case. I find what I did so simple and self-evident that I thought I could keep this to myself.[9]

Vincent brought Sien into his little apartment to provide a safe place to live, stretching an already meager allowance to accommodate her, her little daughter, and soon a baby boy. He did what he could to strengthen her and share her burden, even though Vincent was ill too at the time and actually had to be hospitalized for several weeks. But he had arranged everything for Sien's confinement, and in a true act of consolation, was by her side upon the delivery of her baby.

Vincent nursed Sien back to health after the birth of her son. He wrote to Theo how moved he was on seeing her in the hospital bed with her newborn sleeping beside her. And he described how he hung prints on the wall next to her bed to surround her with the narratives that had always nurtured and comforted him in times of difficulty. One such

REMBRANDT VAN RIJN, *THE HOLY FAMILY BY NIGHT* (DETAIL), C. 1642-1648

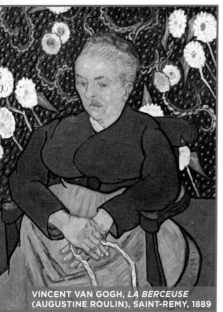

VINCENT VAN GOGH, *LA BERCEUSE* (AUGUSTINE ROULIN), SAINT-REMY, 1889

image was that of *The Holy Family* (also known as *The Carpenter's Family*) by Rembrandt. In this painting an old woman is rocking a baby in a cradle while a younger woman reads by the light of a candle. By calling this painting *The Holy Family*, Rembrandt had succeeded in relating the picture of an ordinary grandmother rocking her grandchild to the Nativity scene where Anna, the mother of Mary, is rocking the infant Jesus. An ordinary family is imbued with the holiness of a biblical story. And because it is such an ordinary scene, we can identify with the setting. The insight we receive is that our own stories are holy ones too. To make this clear, Vincent elaborated on this painting years later in Arles. He took Rembrandt's ordinary yet biblical *Holy Family* and went a step further. He painted *La Berceuse* based on the figure of the grandmother in Rembrandt's painting. The model for this cradle rocker was his friend Madame Roulin. She became the holy mother rocking her holy child. Now, in The Hague, in a low-income hospital, Vincent was overcome by the sanctity of the image of motherhood on seeing Sien holding her newborn child—a true nativity!

Once Sien left the hospital and returned to Vincent's apartment, Vincent wrote to Theo how he reveled in the warmth of this little family circle. The baby's crib stood beside him as he worked on his drawings.

> If one feels the need of something great, something infinite, something where one feels one can see God, one need not go far to find it. I think I saw something—deeper—more infinite—more eternal than the ocean in the expression of the eyes of a little baby when it awakes in the morning—or laughs because the sun is shining in its cradle. If there is a "ray from on high," it could be found there.[10]

And Theo, working hard in his art dealership in Paris, kept sending the payment for the rent and the food. From this allowance Vincent also had to buy his art supplies, which now included paints and brushes, for he had begun to experiment with color. Vincent continued writing to Theo, asking for his allowances to be increased or sent earlier, while explaining what he was attempting to do—saving a life while drawing and painting life in all its reality; he was creating paintings that would point beyond the ordinary to the sheer miracles.

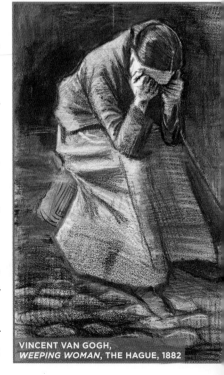

VINCENT VAN GOGH,
WEEPING WOMAN, THE HAGUE, 1882

Sorrow. After sketching Sien over and over again, Vincent made one of his most striking and expressive drawings. He penciled in the bottom margin the word *Sorrow*. In this sketch he applied a simple contour line to trace Sien's bare, crouching body. The sensitive, expressive quality of this line made the drawing no longer just an actual representation of Sien; it became a statement

about Sien and an image expressing the collective pain that many around him suffered and bore. In this drawing, art achieved a symbolic quality that nevertheless was based on a study of a real human being. Here, like in Millet's *Sower*, Vincent felt that art rose above present-day realism and expressed a timeless, universal quality. He saw more soul in those who endured hardships, and this is what he attempted to show with the simple and stark outline of Sien's body. He hoped that his drawings would not convey shallow sentiments but deeply felt human emotions. According to Vincent, if a painting had soul in it, then it was a successful and worthwhile piece of art.

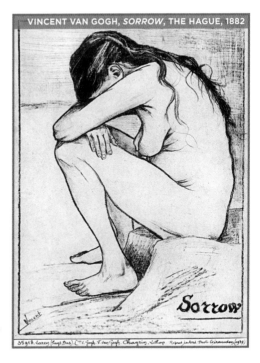

VINCENT VAN GOGH, *SORROW*, THE HAGUE, 1882

Vincent saw *more soul* in the natural environment too. Every time Vincent took his long walks through the countryside, he exalted in the gentle purples of heath fields or described with enthusiasm the sparkling effects of a late afternoon sun reflected in countless puddles along a muddy lane. And he saw metaphors everywhere:

> Sometimes I yearn to paint a landscape, just as one has the desire for a long refreshing walk, and then I see in all of nature, in trees for example, a real expressiveness and a soul. A row of pollard willows sometimes reminds me of a procession of orphaned almshouse men. Young corn can express something indescribably pure and gentle that awakens in me the same emotions as when

I see a sleeping child, for example. And the trodden-down grass on the side of a road looks weary and covered in dust like the inhabitants of an impoverished neighborhood. Last time when it snowed I saw a row of frozen Savoy cabbage that reminded me of a group of women in their worn-out skirts and old shawls standing early in the morning at a cellar where hot water and fire could be bought.[11]

An ambition founded on love. Vincent's time and energy were consumed by two ambitions—his drive to master his drawing skills and his desire to console and ease the suffering of the people around him. "As to my feelings on how far one may go in a case where one should be concerned about a poor, abandoned, sick creature, I already told you on an earlier occasion, and repeat it . . . as far as Infinity."[12]

Much of his time and his resources were dedicated to helping Sien and her children. And whatever strength he had left was used to create an art with more soul. His life in The Hague took on a similar quality as it had in the mining villages of the Borinage—he sacrificed his own well-being for the welfare of others and now for his art as well. Meanwhile, Theo too was under tremendous stress to work hard so he had the means to cover Vincent's expenses as well as to support their parents, in addition to his own upkeep. Yet even though the care for Sien and her family demanded sacrifices from Theo and put a heavy burden on Vincent, Vincent revealed to his brother that he wanted to make a full commitment by marrying her. Theo was opposed and eventually told Vincent that he could no longer support him if he stayed with Sien. The few artist friends in The Hague turned away from Vincent, for they could not accept his eccentric behavior and did not understand his motives. One of his former superiors at the Goupil gallery with whom he had resumed contact went so far as to tell Vincent that he was wasting his time. First, how dare he bring shame on his family by living with a woman of ill repute? And furthermore his sketches did not amount to anything. He should give up his desire to become an artist. Yet, despite

these accusations, Vincent hoped that he could at least convince Theo that he had to continue with his drawing. From The Hague, he wrote,

> You must understand clearly how I consider art. In order to grasp the essence, one has to work long and hard. What I want and what I aim for is damned difficult and yet I believe that I do not aim too high. I want to create drawings that will touch some people. . . . Whether it is in figures or in landscapes, I do not want to express some sentimental melancholy but serious sorrow. In short, I want to progress so far in my work that people will say, that man feels deeply and that man feels tenderly. Despite my so-called coarseness—you understand—maybe precisely because of it. It may seem pretentious to talk like this now, but that is also the reason why I want to push on forcefully. What am I in the eyes of most—a nonentity or an eccentric or a disagreeable man—someone who has no position in society and will not have one, in short a little lower than the lowest.
>
> Well then, if this were exactly like that, then through my work I would like to show what is in the heart of such an eccentric, such a nobody.
>
> This is my ambition, which is based less on resentment than love in spite of everything, based more on a feeling of serenity than on passion.[13]

Leaving The Hague. Vincent never did marry Sien. Theo succeeded in convincing his brother to leave The Hague. And Vincent, after living with Sien for more than a year, saw that she could not withstand the pull of her previous life. She was pressured by her own family to go back to prostitution, where she would make more money. When Vincent left Sien, it was in a mood of dejection. He had failed in his attempt to give Sien a chance for a better life. He pleaded with her to be at least a good mother to her daughter and baby son. It was difficult for Vincent to abandon the children, especially the little boy who had become attached to him. He left behind the only semblance of a family life he would ever have.

Once again Vincent was on the move, this time escaping to Drenthe, a desolate place in a northeastern province of the Netherlands. He had set his foot on the artist's path in the Borinage. In The Hague he had continued on this path while at the same time reaching out to those in need. In Drenthe Vincent completed his transformation from missionary to an artist with a mission. Art was to become the main language through which he would continue his ministry.

IN THE HEART OF THE COUNTRY (NUENEN)

Painting rural life. After three months in the remote peat country of Drenthe, where he slowly felt his vitality revive, Vincent returned to his parents' home, this time to the new parish of Nuenen. Warily, Vincent's parents received their prodigal son back into their midst. Vincent knew his parents could barely tolerate his presence. Unlike the prodigal son of the biblical parable, he was not embraced unconditionally. They could not abide by his eccentric demeanor and the increasing intensity with which he went about his work. In turn, Vincent became withdrawn and unwilling to integrate into his family and parish life.

As before in Etten, he was drawn to the hardworking peasants laboring in the fields. He likened his efforts of sketching to that of tilling the soil and wrote to Theo that he had no other desire than "to live deep, deep in the heart of farming country and to paint peasant life. I feel that I can create my working environment there, and so I shall calmly keep my hand to the plough and cut my furrows."[14]

He continued improving his skills by sketching tirelessly the country folks living in and around Nuenen, emphasizing their essential and vital role in the whole web of life. Vincent was clearly in his element, savoring every moment he could spend in nature, drawing constantly, only pausing when he had the urge to let Theo share in his enthusiasm: "The figure of a digger—a few furrows of ploughed soil—a little bit of sand, sea and air, are serious motives and so difficult, but also so beautiful that it is a worthwhile effort to devote one's life to render the poetry that is found in them."[15]

The weavers. He was often found inside the homes of weavers. They worked silently, trapped by their large looms, for hours on end with poor lighting and little to interrupt the rhythmic movement of their shuttles. These weavers still eked out an existence as one of the last remnants of a hand-laboring class of workers before machines would take over their trade. Sitting inside their somber cottages, dwarfed by their looms, the weavers also symbolized a life lived in the prison of poverty and convention. Vincent created a whole series of drawings and paintings of weavers, ever intent on portraying more metaphorically the qualities and meaning of their existence. The weavers must have been surprised at Vincent's intense interest in their manual craft. How well did they tolerate this man sitting in close quarters in their cramped huts, intent on capturing their every move for hours on end? This was something they had never experienced before. Vincent, as a fellow laborer, took his task of portraying them seriously and explained in a letter to Theo,

> We must continue to give something real and honest. Painting peasant life is something serious, and I, for one, would blame myself if I didn't try to make paintings that would give serious

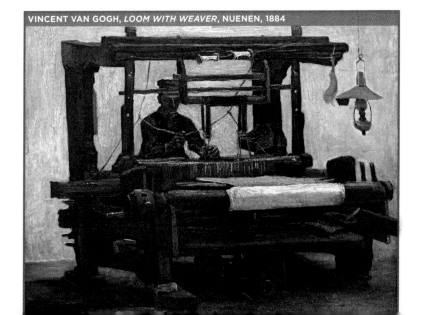

VINCENT VAN GOGH, *LOOM WITH WEAVER*, NUENEN, 1884

things to think about to people who think seriously about art and about life. . . . One must paint the peasants as being himself one of them, as feeling, thinking as they do themselves.[16]

The peasants. As Vincent became more skilled at using contour lines to capture what he observed, he began to draw more from the center. He looked increasingly at the substance of his subjects rather than at the boundaries between the figures and the space they occupied. Drawing from the center gave his figures more of a physical, corporeal presence. He had no use for technical subtleties of the academicians whose figures were correctly rendered yet often lifeless and without any sensitivity to the underlying character of their subjects. He wanted his diggers to dig, his weavers to weave, and his sowers to sow. He was striving to paint what he called a truly "modern" painting where the intimate character, the real action of his subjects was recognized.[17] He elaborated on this when he wrote, "What I am trying to get at is not that I can draw a hand but the gesture, not a head with mathematical precision, but the over all expression. . . . In a word, life."[18]

Such pictures portrayed rural life truthfully and unequivocally as it was lived everywhere throughout the ages by the humble peasantry. Vincent could only give voice to this essence by first capturing what he saw with the most fundamental art elements—line. Once the lines had

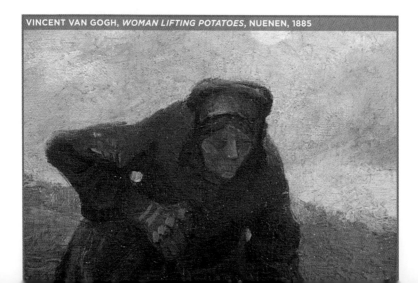

VINCENT VAN GOGH, *WOMAN LIFTING POTATOES*, NUENEN, 1885

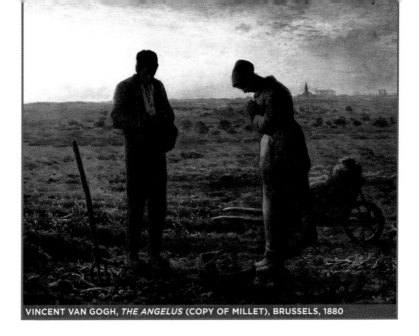

VINCENT VAN GOGH, *THE ANGELUS* (COPY OF MILLET), BRUSSELS, 1880

found a way to describe his subjects, he could trust his hands and his eyes to capture what he could see with his heart—in other words, what lay between the lines: *the more soul.* By drawing the souls of the peasants, he gave expression to his own, making them an extension of himself.

The potato eaters. Having gained his foothold in Nuenen, Vincent embarked on his most ambitious effort yet. He intended to create a portrait of a family eating a meal together. Vincent was inspired by three artists who he felt had succeeded in using art to uplift the ordinary into the realm of mystery and expressive allegory. Millet's *The Angelus* and *The Sower* were examples in which simple acts of prayer and sowing seeds achieved a timeless symbolic quality.

Rembrandt had immortalized the sanctity of a shared meal in his *Supper at Emmaus.* And Jozef Israëls, a painter of rural life Vincent esteemed as the Dutch Millet, had succeeded in expressing the sacredness of a humble peasant family gathering around their supper table in a *Peasant's Meal at Delden.*

Vincent befriended a family of potato farmers, the De Groots, and began to study the features of each member of their household. Here, as with the weavers, he spent hours in their home, where he could observe them going about their daily chores. He sketched and painted

portraits of the family members over and over again so that he could capture every nuance of their work-worn faces and callused hands. One can imagine that a special relationship developed between Vincent and this family. In order to draw them, there had to be a degree of trust, acceptance, and personal dialogue. He was not intent on drawing them in a photorealistic manner as a portrait of a particular family. He wanted to express the attitude and frame of mind of any family of peasants sitting down to eat their meager supper inside a dark, smoke-filled cottage. Vincent hoped to convey the essence and dignity of these potato farmers who lived so close to the source of their livelihood. His painting had to point to the reality that the fruits of their labor not only sustained them but also those who lived far from this rural setting. It was not going to be an idealistic description of familial togetherness. It was to be a portrait of people who ate together, united by their kinship and in their labors, but were too tired to talk after a full day in the fields. It had to be a situation that in its ordinariness could invite people to identify with it. And because this ordinariness was displayed on a canvas, it would uplift a simple communal meal to a level of extraordinariness.

There is an element of symbolism that links *The Potato Eaters* to the religious act of partaking in a Eucharistic meal (Communion)—here

JOZEF ISRAËLS, *PEASANT'S MEAL AT DELDEN*, 1885

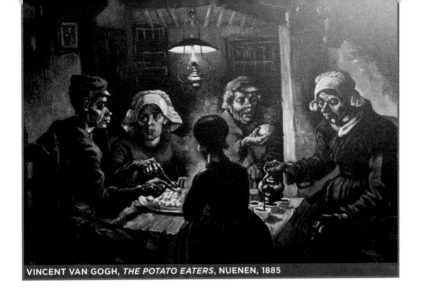

VINCENT VAN GOGH, *THE POTATO EATERS*, NUENEN, 1885

Vincent's unwavering faith is expressed in a subtle way. These simple peasants are united around a frugal meal to receive nourishment for their bodies and souls. This image of silent solidarity symbolized for Vincent the light shining in the midst of darkness. In a surrounding of coarseness and poverty, within smoky air and soot-covered walls, Vincent saw beauty and the nobility of the human heart. He wanted to have these qualities become evident in the confinement, of the peasant's hut during their evening meal. Explaining the work he was laboring so hard to complete, and being aware that it was coarser and more realistic and less romanticized than what was being painted by his contemporaries, he wrote to Theo,

> I have tried to emphasize that these people, who by the light of their little lamp are eating their potatoes, who with the same hands that are reaching into the dish have tilled the earth, and so this painting speaks of manual labor and thus of having honestly earned their food. I wanted to make people think of a whole different manner of living from the way we civilized people live. I also wouldn't care if not everyone would find it beautiful or good.[19]

It would do city people good to witness the life of the simple peasant folks, even if only through a painting. These peasant paintings had to figuratively smell of the pungent odor of fertile soil and manure. Such

paintings had to convey the aspects of rural life as closely as possible, These paintings were created to honor lives lived sacrificially and dutifully by people who were real and honest and valuable. In order to relay such a powerful message, Vincent had to create his paintings with a will, with feeling, with passion, with love.[20] In order to do so, he had to live in "those huts day in and day out, being out in the fields just like the farmers—in the heat of the summer, withstanding snow and frost in the winter, not indoors but outside, and not for a walk, but day in and day out just like the peasant himself."[21] With *The Potato Eaters* Vincent gives us a glimpse of one of the most common experiences of being human, that of sharing a communal meal around a table.

Vincent's time in Nuenen came to a close with this portrayal of *The Potato Eaters*, which he could rightly say was made from the heart of farming life—it is original.[22] Soon after its completion, Vincent's father died of a heart attack. With the sudden loss of Pastor van Gogh, his family also lost their home since the parsonage had to be vacated for the new pastor. Feeling that he had accomplished what he set out to do—to become a peasant painter who had learned to draw life as he perceived it—Vincent was ready to move on, hopeful to emerge as an artist in the larger art world.

He left his native country, never to return again. He spent a brief time in Antwerp, Belgium, where he sought some formal art training in an art academy. However, realizing that he had established his foundation through the years of drawing from life and wouldn't benefit from academic lessons that had him copying plaster casts, he longed to be among real artists. With little prior notice, he boarded a train for Paris, where he hoped to join Theo, who had by now established himself as an art dealer of some repute for the new generation of artists: the impressionists. Theo was ill-prepared for the tornado of creativity and energy that was about to touch down in his Paris apartment.

Consoling and Being Consoled

During our ministry in northern Vermont, I remember sitting in church one Sunday morning with tears running down my cheeks. It had been a very difficult and disturbing week. We were caught in the conflict between the church elders who had chastised us for welcoming troublemakers—teenagers from other communities—to meet for youth fellowship in their church basement. Leading up to this Sunday we had dealt with intense confrontations, angry phone calls, and upset youth. I was now even more unsettled as I sensed the atmosphere of hostility emanating from a few people sitting in the pews behind me. Steve was noticeably distressed during the delivery of his sermon too. As I sat there feeling miserable, I also realized that I had forgotten to light the candles on the altar. My only blooming geranium, which I had nursed all winter long, drooped pathetically next to the unlit candles. And the opening hymn played laboriously by the old organist on the electric organ sounded more like a funeral dirge. Our emotional state was well expressed in these outward circumstances!

Once back in the safe haven of our little parsonage that afternoon, Steve and I sat silently together on our threadbare couch, feeling dejected and discouraged. Where had we gone wrong, what had we not understood or neglected to do in our parish work? Would the elders ask us to leave? Our commiseration was suddenly interrupted by a loud knock on our front door. We were reluctant to open it. But we did, and there in the doorframe stood Stu, one of the older parishioners of

the conflicted church. Stu had tears in his eyes and clearly looked troubled. And then he simply reached out and embraced us. The only thing Stu said was that he cared deeply for us. That was it. We had no time to respond. He turned around and left us standing there in the doorway. It took a while to let what had just happened sink in. Stu had witnessed our distress in church that morning. And now he had come to let us know that he acknowledged our pain. Years later the memory of that moment still floods our souls with the same feelings of affirmation, encouragement, and affection that uplifted us that Sunday afternoon.

WHEN WORDS FAIL

We lived through some hard and tragic times during our years of ministry. While serving the churches in northern Vermont, we arrived back at our humble parsonage after a short trip one stormy and wicked-cold evening during mud season (the in-between time of the winter freeze and the spring thaw). Needing some supplies for supper, Steve walked across the road to the general store. Several people were hanging around the counter; they looked grieved. When Steve asked what was wrong, one of the women responded, "The little Adams boy's gone missing." A search had been launched by men in the community as well as by the boys of the local Boy Scout troop who had been attending a supper meeting that evening in the elementary school auditorium. Steve asked where the Adamses lived. Within minutes Steve came over to inform me, then jumped back in the car and drove to the parents' house. I stayed at the parsonage with a sense of foreboding.

When Steve arrived at the home of the parents, the little boy had just been found. He had been playing outside, slipped on the snowy embankment, and fallen into the swollen brook at the end of the yard and drowned. Looking up, the searchers recognized Steve and asked him to tell the parents. In the cold blue light of that home, Steve had to give the unbearable message to the parents. Not comprehending

the enormity of his loss, the father asked Steve to make sure his seven-year-old son was wrapped in a blanket. Steve remained with the parents for a long time that night.

A few days later, the sanctuary was overflowing with people for the little boy's funeral. The whole community was touched by this tragedy. I came to the church late, sat in a back pew, and left before the service was over. I was at a total loss for how to confront such unspeakable grief. What should I say? I dreaded meeting the parents. Yet, more than anything, I yearned to reach out to them, especially to the young mother I had just barely met.

My fear built a strong, invisible wall around me. For the next few days I barely stepped out of the parsonage except to get in my car to go to my work at the college. I sent Steve to the general store for groceries. I felt miserable in my self-inflicted confinement, yet very aware that my misery was nothing compared to that of the parents. Then one afternoon while I was hiding out in the parsonage, there was a loud pounding on the door. I rushed to open it and—stood in front of the person I had been avoiding these past days.

Before I could say anything, Marcia threw herself at me, her arms clinging to my neck, sobbing and crying out, "I can't take it anymore!" We stood in the doorway for a long time, just holding each other, crying together. No words were necessary during that long embrace. In her overwhelming despair she had come to me. And all I had to do was open the door and open my heart to her pain. In the hours that followed we sat together and she talked and cried more. And I listened and could offer the sanctuary of our little parsonage, away from her home where she couldn't bear being alone during the day. I realized that there was nothing I could say that would make things better, that would change what had happened. But as she talked with me and others in the community, I understood that she could begin to feel the process of healing through the consolation she received from those willing to sit with her and cry with her. She had become aware that she was not alone in that

place of darkness. She had her strong faith, but she needed the others to be *cum solus* with her.

When Marcia came pounding on my door in desperation, I was given the opportunity to be a buoy to one who was about to drown in her grief. It was a moment of grace when no words were needed, where consolation flowed both ways. And I feel that Marcia gifted me with what Vincent would have termed "more soul." Henri's words, taken from one of his books, can be applied to that experience: "Every human being does have a great, yet often unknown, gift to care, to be compassionate, to become present to the other, to listen, to hear, and to receive. If that gift would be set free and made available, miracles could take place."[1] In that remote part of northern Vermont, miracles had truly been taking place.

SEEKING WARMTH

Many years after having left northern Vermont, after spending three years in New Haven and three further years in St. Louis, we settled in Queens, New York, with our three boys. Our front door remained locked for safety reasons, but the doorbell rang often. One day as I was busy in the kitchen in the back of the house, I suddenly realized that I had forgotten to lock the front door. I quickly made a beeline through the dining room and living room into the front hallway and turned the lock. As I hurried back through the living room to attend to my pots cooking on the stove, I stopped in my tracks. There was someone sitting on the couch.

After the first wave of fright washed over me, I recognized Guy, a Vietnam veteran from the neighborhood. He sometimes rang the bell of our parsonage hoping for a chance to visit. Sometimes I invited him in for a cup of coffee and to talk for a while. He was a brilliant man, mild mannered, witty, and jovial. He spoke French fluently, had read all the French classics, and was especially drawn to the works of Victor Hugo, particularly *Les Misérables*. He would often come to church on

Sundays. But he was a deeply troubled man, suffering from what we now know as post-traumatic stress disorder, often having night terrors depriving him of sleep. He had witnessed the violent deaths of his closest friends in Vietnam. He was unable to work and lived with his elderly aunt.

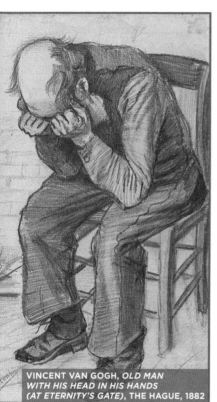

VINCENT VAN GOGH, *OLD MAN WITH HIS HEAD IN HIS HANDS (AT ETERNITY'S GATE)*, THE HAGUE, 1882

This day, finding the front door of our home unlocked, he had entered on his own and had made himself comfortable in the warmth of our living room. Home, warmth, and comfort, both emotional and physical, were things he yearned for. He was lonely, and it troubled me that we could not do more for him. We were grateful that he seemed to feel at ease with us. Often he and I spoke French together. But I was a bit wary of his presence around our three young sons. That day in our living room he stayed for a while to enjoy the fire burning in the fireplace. We had a cup of coffee together and talked. But then I had to ask him to leave, which he reluctantly did.

Not long afterwards, his aunt died and he was evicted from her apartment. Steve worked with him for months to find ways to integrate him into the VA services of the city, unfortunately to no avail. Guy had to seek out shelters and soup kitchens in the city.

Vincent made drawings of people like Guy. One such man, "Orphan Man," from the almshouse of The Hague is immortalized in *Worn Out*. In years to come we encountered so many of them and tried, not always successfully, to be present to them. After Guy's eviction from

his aunt's apartment, he felt some consolation that we adopted his beloved cat, Tom.

SHELTER FOR A NIGHT

During an Advent season, we had unannounced visitors one evening. Our family was enjoying a cozy time around the fireplace while our evening meal was baking in the oven. It was our tradition to read stories in anticipation of the celebration of Christmas. We just had finished reading the Nativity story about Mary and Joseph arriving in Bethlehem and looking for a place to stay. We spent some time talking about the homeless people we knew and called by name and about the unknown homeless that gathered on the thoroughfare near our parsonage. We asked what we would do if Mary and Joseph came to our house. Suddenly the doorbell jolted us out of our story time and musings. Opening the door, Steve found a young man and woman standing on our doorstep. They appeared to be in their late teens. They were cold and asked for help in finding a place to stay.

Steve invited them in, and the boys helped put two more place settings around our kitchen table. Being steeped in the Gospel narrative made us all the more accessible to these visitors. I don't remember what they told us about their predicament. At the time, we were just incredulous; was this really happening? We could tell they were cold and hungry, and they seemed to be poor—and the young woman was visibly pregnant.

We sat around our small kitchen table and ate together. Then I drew a warm bath for the young woman, and we showed them both to our spare bedroom. They left the next morning after breakfast with some money for gas. Thinking back and imagining this happening to us today in the twenty-first century, would we be more adamant at questioning them, maybe contacting the local police or social authority? But at that time we did what the age-old story told us about; we gave them a room in our "inn."

Henri said that Vincent did not have a solution mentality; he just met those in need where they were. We didn't find a solution to the plight of these two people. We just gave them what they needed at that moment—a nutritious meal, a warm bed for the night, some kindness, and consolation. But there was a risk in taking them in. That is why so many doors are shut to the itinerant people in our neighborhoods. Steve and I stayed awake through the night listening for any motion or noise. We were concerned because we didn't know these strangers and because we wanted to make sure our children were safe. But our sons saw that these two unknown people were treated with dignity and that it didn't take much effort to offer hospitality. We hoped that the memories of that night and morning would help guide them—our young visitors and our sons—onto a good, compassionate path.

Part Three

Comfort

The compassionate offer comfort
by pointing beyond the human pains
to glimpses of strength and hope.

HENRI NOUWEN

God is the constant love that breathes in
all life I see. Oh, that His wisdom
and compassion lived in me.

THE BOOK OF ANGELUS SILESIUS, FREDERICK FRANCK

In a picture I want to say something
comforting, as music is comforting.

VINCENT VAN GOGH

Vincent Offers Glimpses of Hope

Three quarters of the way through Henri's course, and leaving the darker climate of Holland behind us, the slides of Vincent's first paintings created in France shone with a wholly different light. We were invited to walk among the blooming orchards of Arles where the fragrant odors of blossoming fruit trees replaced the pungent smells of manure and wet Dutch soil. Vincent's paintings and drawings still conveyed images of the everyday and the mundane, but they were not somber. Now his work started to become intensely colorful and radiated with a forceful vitality. Symbolically, they pointed to the divine source that could dispel the darkness and offer hope.

Henri had laid Vincent bare in word and in image. Now even though the paintings were mere projections on a screen, the traces of Vincent's energetic brush strokes like tracks in soft soil were clearly discernable in the thickly applied paint. Seeing these imprints made it easy to imagine him standing before his canvases. We followed the movement of his paintbrush as he laid down the lines and shapes of what he saw before him. Vincent had become present to us. The artist Eugene Delacroix (1798–1863), I feel, aptly described the connection that can exist between painters and the viewers of their art: "To be understood a writer has to explain almost everything. In a painting, a mysterious bridge seems to exist between its painted subjects and the spectator's spirit."[1] This is what Vincent achieved. He formed an emotional connection between us and him. As Henri pointed out, Vincent had found a way to make our common bond visible.

THE ARTIST AS SEER AND CONTEMPLATIVE

Henri also spoke about Vincent as being a seer, one "who saw and wanted us to see with him." As he progressed in his life and art, his sun-covered landscapes and glowing wheat fields, olive orchards, cypresses, radiant people, sowers, and reapers—all spoke their own wordless language in the images he created. "In the midst of darkness he saw light. In the midst of ugliness he saw beauty. In the midst of pain and suffering he saw the nobility of the human heart. He saw it, and he burned with desire to make others see it."[2] Vincent felt that the deepest religious expression should be born from actual observation and personal experience.

Henri had entered so deeply into Vincent's world that he had discovered how Vincent consciously used all his senses in this search for God. While working in the damp soil of Holland, walking for hours along country lanes in England, or living among the homeless and the destitute, Vincent's mind and soul were constantly searching for and questioning the presence of God. This was what drew Henri to Vincent on an ever-deepening level. Henri saw how Vincent was blending all that he had experienced into his expressive paintings, where he could freely interpret what his senses perceived. In Provence, Vincent responded to the bright sun, which intensified his perceptions by personalizing what he saw: the struggles of the gnarled olive trees and the maturing of the golden wheat were nature's qualities mirrored by his own experiences. Nature was revealing itself to him. All that surrounded him was quenching his sensuous and earthy longing for God. All of creation seemed to be permeated with God's presence.

Curiously, while in Arles, Vincent created a self-portrait of himself looking like a bonze—a Buddhist monk. While inspired by his readings of books about Japan, the portrait alludes to Vincent's affinity for Japanese artists who could study a blade of grass that in turn led them to paint the great aspects of nature and the human figure. The portrait also suggests that Vincent, in his contemplative observations and just

like the Japanese artists, had come to understand nature's revelation—that everything in nature was connected to and a part of the whole of creation, which led him to paint with a more universal and holistic sensitivity. When he lived for a year in the asylum of the monastery Saint-Paul de Mausole in Saint-Rémy, the monastery gardens and cloisters invited him to truly enter into monastic contemplation. Vincent painted some of his most symbolic and numinous paintings in the gardens of the asylum. These paintings inspire us to become contemplatives too.

Henri said that like a monk who no longer needs to struggle to make God known, Vincent radiated his faith in the Something on High through the expressive lines and colors and subjects of his paintings. As a monk who is never separated from his sorrow, so Vincent's joy remained deeply connected with his own struggles. Vincent's joy reverberates though his sunflowers, his golden wheat fields, the spirals in the sky of his *Starry Night*. Vincent's sorrow is expressed, for example, through broken boulders and a deep chasm in the earth, as is seen in the *Entrance to the Quarry*. Vincent, as a true contemplative, could see beyond the surface of things and reveal the metaphorical implications of the material world. He could sense the eternal message in the temporal. This is what he hoped to be able to convey through his art.

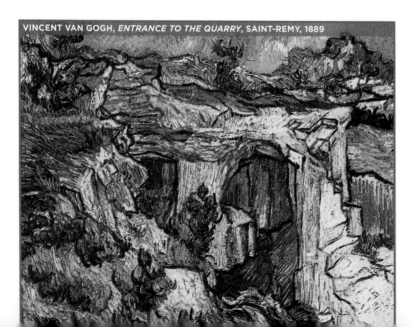

VINCENT VAN GOGH, *ENTRANCE TO THE QUARRY*, SAINT-REMY, 1889

If it were not that I have almost a double nature, that of a monk and that of a painter . . . I would have been reduced, long ago, completely and utterly, to the condition of madness. . . . Yet even then I do not think that my madness could take the form of persecution mania, since when in a state of excitement my feelings lead me rather to the contemplation of eternity and eternal life.[3]

THE ARTIST AS INTERMEDIARY AND MYSTIC

For Vincent, art did not just refer to the created works, it also encompassed the whole experience of the interactions between the artwork, the viewer, and the artist. While he was still a missionary, he had written that he wanted to bring peace to the poor and help them reconcile with their existence on earth. As an artist he still had this intention, hoping that his paintings would connect in a mysterious way with the viewer so as to offer greater understanding, a deeper capacity for empathy, a sense of consolation and hope.

Here it was that Henri discovered deep calling to deep (Psalm 42:7). Vincent had somehow transcended art and become an intermediary. Henri understood that Vincent's art had become an act of hospitality. Vincent invited "people to experience their connectedness with the creation" and the whole of human existence. Henri explained that "to the very end Vincent pursued the great mystery that hides behind the appearances of created things." This was the secret he labored so hard to reveal in his paintings, namely, that the divine was present in all the realities of life. Vincent's art was imbued with his experiences of fully tasting these realities. Simple images of Vincent's painted sowers, for example, express metaphorically that "when the ground is broken, new seeds can be sown." Henri interpreted this metaphor, one of his favorites, by saying that through acknowledging our brokenness, our frailties, we are able to come to new insights. "When people reach out to each other in mutual openness," in mutual suffering, "tensions evaporate, smiles shine through tearful eyes and the presence of something new and

eternally fresh is sensed."[4] New life can emerge from brokenness. Henri understood through his in-depth study of Vincent's life that indeed a renewed purpose and joy in life comes forth from the fellowship of those who are wounded and weak. The vulnerable have so much to teach about the reality of life and our connections as finite beings. Henri explained that this is the comfort Vincent offered. It was a solace to Henri and to his own wounds too. Henri's insight was captivating. He made us realize that in his paintings Vincent pointed beyond the struggles of daily life to a source of abounding strength and comforting hope.

The imprints of Vincent's brush strokes created a textured surface that seemed to weave the sowers into the rows of furrows and the reapers into the weft of the ripe stalks of wheat in the fields. A weaving is made of strands of yarn that individually are weak, but when intertwined into a fabric, they become strong. These woven images—the coming together of different strands of colors and lines—express figuratively how Henri spoke to us about comfort as the uniting of human beings to form a new strength together. Henri taught that

> those who come together in mutual vulnerability are bound together by a new strength that makes them into one body. Comfort does not take our suffering away, nor does it minimize the dread of being. Comfort does not even dispel our basic human loneliness. But comfort gives us the strength to confront together the real conditions of life, not as an unavoidable fate, but as an inexhaustible source of new understanding.[5]

So for Henri, Vincent's painted wheat fields with the laborers embedded in them illustrated how comfort happens. It occurs when human beings come to understand how they are a small part that is integrally woven into a whole. And however minor that part might feel, it is important to the entire created tapestry of life.

After viewing slides of some of Vincent's radiant landscapes of Provence, and during one of the last classes, Henri shared with us more of his personal thoughts and insights. He drew us in. He engaged in

informal discussions with us and urged us to share with each other so that heart spoke to heart. In these exchanges the professor-student relationship was transformed into a collegial one. Henri said that

> on the one hand, Vincent definitely was not a man who talked theologically anymore after his early hassles with it [the church], but definitely, I have had this feeling that looking at the paintings and staying with them long enough, and learning about Vincent's life story, it is the light and the sun [in his paintings] that were really bringing me in touch with something that could be called the lighting up of eternity in the midst of life. One of the things that fascinated me was that Vincent was talking about being faithful to nature and energetically worked so that he could break through the iron wall between what he saw and what he wanted to express, and feel and do about it. . . . And he felt that by entering into a closer relationship with nature, and that doesn't just mean trees but also people, you will find something that is true and that is not destined *for the worms*.[6]

Henri was referring to a letter Vincent had written to Theo from The Hague on November 26 and 27, 1882:

> It seems to me that one of the strongest proofs for the existence of "something on high" in which Millet believed, namely, in a God and in an eternity, is the inexpressibly moving quality seen in the expression of an old man like that . . . as he sits so quietly in the corner by his hearth. At the same time, there's something dignified, something noble, that can't be destined for the worms.

Henri repeated that Vincent had "crawled under the skin of people" whether they were the miners walking home from the pit through the snow, an old, sick farmer sitting by his hearth, or the reaper laboring in the intense heat of Provence. Vincent found the holy in the ordinary. Henri, who himself had an incarnational view of spirit infusing life, said that Vincent's "paintings do that for me. . . . They show that there is

something more to life, after all the misery has been dealt with, after all the human pains have been looked at very carefully and long," there is something beyond that transcends the here and now. Henri felt that Vincent was essentially a mystic who could abstract what he saw and then make it more tangible and intelligible in the form of his universal language. Vincent had always felt it to be his duty to make art revelatory. Henri saw that Vincent did this by seeking to disentangle truths inherent in the temporal, in the ordinary moments of life that pointed to the Something on High.

INTERPRETING REMBRANDT

Vincent created one of the most moving paintings while he spent a year in the asylum of Saint-Paul de Mausole in Saint-Rémy. Henri showed us this painting, which is a copy of Rembrandt's *The Raising of Lazarus*. In Vincent's version, the image of Jesus is substituted by the image of a brilliantly radiating sun. Henri said that it was

> the sun, more than *The Potato Eaters*, that has made Vincent famous. The sun casting its flaming light over the wheat fields of the Provence. The sun rising as a fiery ball behind the dark figure of the sower, the sun that replaced Rembrandt's Christ in the rousing painting of the raising of Lazarus. The sun, light in the darkness, light that brightens nature and people, light that calls the dead forth from their graves. Those who see Vincent's sun feel the warmth of his comfort and understand that Vincent's solidarity and consolation make them see the rays of the great sun in their deepest selves. They realize that he was a compassionate man.[7]

Vincent's way of looking at the paintings of Rembrandt opened Henri up to new personal insights and understandings of Rembrandt. From all of Vincent's letters describing his love for the art of Rembrandt, Henri knew that Vincent's admiration for this artist was rooted in the manner in which Rembrandt could fuse ordinary life stories with the

sacredness of biblical ones. Vincent related how he could enter into Rembrandt's or Delacroix's paintings and be touched by their insights and understanding of the biblical parables.

As a priest Henri had a profound connection with biblical stories, so the bond Vincent had with Rembrandt and Delacroix intrigued Henri. Henri noted that by illustrating the truths revealed in biblical as well as personal stories, these artists could use a universally understood language to connect us to our shared humanity and divine vocation. Henri recognized that Rembrandt wordlessly communicated through his paintings. Rembrandt had indeed inspired Vincent in the Borinage to use art as a language to express the deeper commonality that underlies our existence. I personally believe Vincent helped Henri look at paintings and see more deeply into the layered narratives, and Vincent helped Henri fashion an even more profound pastoral understanding of his own vocation. Vincent articulated for Henri how to read the visual arts, but more importantly, Henri was making more personal discoveries as he delved into his theme of compassion.

Many of us who are familiar with Henri's writing may know about his intense involvement with Rembrandt's painting *The Return of the Prodigal Son*. Years after his professorship at Yale Divinity School, Henri visited the Hermitage Museum in St. Petersburg, Russia, where this painting was exhibited. While there, Henri spent hours totally absorbed in this painting. In fact, he spent so many hours rooted to the ground in front of the painting that one of the museum guards brought him a chair. Just like Vincent, Henri was captivated by what he saw. It so enthralled him that from his observations he authored one of his most powerful works, *The Return of the Prodigal Son: A Story of Homecoming*. Henri invites us to become more deeply involved with the parable of the prodigal son too, guiding us in meditations about our own spiritual journey.

Vincent encouraged Henri as Henri encouraged us to understand this parable, as well as others, in ever new, revealing, profound, and intimate ways. They both invite us to spend more time looking in order to see.

8 | VINCENT

Comforting Through Pictures

Vincent's arrival in Paris in March 1886 brought a tremendous upheaval into his brother's life. Theo's apartment began to reverberate with all the passion, enthusiasm, eccentricity, and complexities that comprised Vincent. Their two years of living together in Paris became a challenge for both brothers. For Theo, life became stimulating and turbulent and at times totally unbearable.

Living with Theo gave Vincent the chance to experience the vibrant art life of Paris. The gatherings of artists in the cafés of Montmartre were like a greenhouse for Vincent. Through his discussions with his artist peers, his understanding of color theory that had occupied him intensely since Nuenen could grow and be developed further. He had read Johann Wolfgang von Goethe's treatise on color theory and Eugene Delacroix's writings on the mysterious dynamics of color. He increasingly learned that color was a force to be reckoned with and that "color has a more mysterious and perhaps a more powerful influence: it acts, as one might say, without our knowledge."[1] Scientists, physicists, and artists were discovering the new properties of the vibratory nature of light and that the scattering of light waves produced colors. Artists tried to translate these new theories and insights onto their canvases where dabs of color were now optically mixed into countless color variations making their paintings seem to vibrate and come alive.

Vincent joined in the excitement of all these color experiments and in the enthusiastic admiration of Japanese art. The art market in Paris

had become flooded with the Japanese ukiyo-e wood-block prints after Japan ended its isolation from the rest of the world in the mid-1800s. Art dealers and artists alike ardently collected these pictures of the "Floating World"—scenes celebrating the transience of daily life. The style of Japanese art with its saturated hues, unusual composition, and subject matter had a strong impact on the manner of painting of the avant-garde artists in Paris.

By the time Vincent arrived on the scene, the impressionists, as the new generation of artists became known, had begun to emulate the Japanese artists. Since these artists looked to nature for their inspiration, the Parisians too began to flee their studios and the stifling halls of art schools, breaking their bond with the strict regulations imposed on them by the French Academy of Art. Copying plaster casts and painting historic events were no longer seen as pertinent and adequate to respond to the changes taking place in society. With the newly invented paint tubes that eliminated the tedious grinding and mixing of pigments in their studios, artists were liberated to carry their painting equipment out into the open air. With the sunshine reflecting dazzlingly off the river Seine, they began to paint Parisian life as it unfolded before

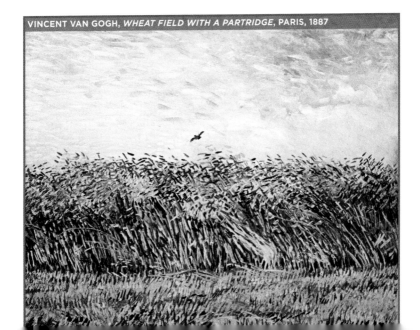

VINCENT VAN GOGH, *WHEAT FIELD WITH A PARTRIDGE*, PARIS, 1887

their eyes—in the boulevards and parks, in the cafés, along the banks of the river, and in the many small forests dotting the countryside.

Immersed in the Parisian hothouse of new art trends and ideas, Vincent gleaned much of what led him to the painting style by which we recognize him today—the broad visible brush strokes of thick paint placed side by side so that color variations are blended by the eyes of the beholder. But after two years, the often intense arguments within the artists' circle and the late nights spent drinking had begun to wear Vincent down physically and emotionally. He yearned to return to the countryside where he could partake once again in the rhythms of the natural world. He wanted to live the lifestyle he believed the Japanese artists exemplified: living simply and mindfully, and creating an art inspired by nature. This was not a new desire, for he had written years earlier in The Hague, "It is the painter's duty to delve deeply into nature, and use all his intelligence to express his feelings in his work so that it becomes comprehensible for others."[2]

Returning to Holland was no longer an option. Now that he had also discovered the powerful effects of vibrant colors, he wanted to travel to a place where the atmosphere was bright. In Holland he had lived with the somber colors of its climate and latitude. Living there had brought the realization that the people yearned for more light. He wanted to paint colors that were intensified by a powerful sun so his paintings would literally and figuratively brighten the dark corners of people's lives.

MORE LIGHT (ARLES)

Wrestling with nature. By February 1888 Vincent was on a train heading south in search of a place suffused by sunlight. After hours of travel and gazing out the window, as the train stopped at the station in Arles, he noticed blooming orchards sparkling under a dusting of late winter snow. He had intended on reaching Marseille in the far south, but the sights he beheld prompted him to spontaneously disembark. He succeeded in finding a small house to rent and wrote enthusiastically to

Theo that he wanted to make the small house into a real artist's house where everything from the chairs to the pictures would have character. He also hoped that his house would be a center for a community of artists as well as a refuge for struggling colleagues, just as he had offered his meager little apartment in The Hague as a shelter for his models invited in from the street.

Vincent painted three hundred paintings during his one-year stay in Arles, but only a few show the Roman monuments and ruins, the quaint cobblestone alleys, and the medieval buildings for which Arles is famous. Vincent was not interested in painting these ancient relics. He was, after all, a modern painter, one who sought to create paintings of everyday life. He wanted to paint people at work, the changing seasons, and the blooming flowers, as exemplified in the Japanese prints he admired. Some of his paintings do show medieval cobbled streets, but included are present-day workers digging trenches. He also painted the famous Langlois drawbridge silhouetted against a blue sky. Here too Vincent draws our attention to people attending to their daily tasks—local housewives pounding their wash against the stones on the bank of the Rhone River just below the bridge.

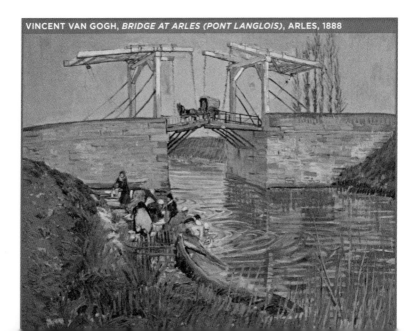

VINCENT VAN GOGH, *BRIDGE AT ARLES (PONT LANGLOIS)*, ARLES, 1888

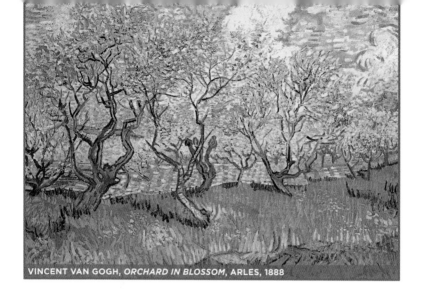

VINCENT VAN GOGH, *ORCHARD IN BLOSSOM*, ARLES, 1888

Vincent was most inspired by what lay beyond the remnants of the ancient city walls. He was drawn to the orchards, fields, and gardens, the places where peasants were at work. Once again he walked for miles through the countryside shouldering his rolled-up canvases and his easel and paints.

The natural scenes that compelled him to set up his easel and paint were subjects that affected him aesthetically and emotionally. His paintings became portrayals not only of the observed but also of the felt.

Nature's secret. Those blooming orchards that had enticed Vincent to get off the train wholly absorbed him soon after his arrival in Arles. Canvas after canvas was filled with portraits of the pink peach trees, the yellow-white pear trees, and the delicate blossoms of almond trees. Vincent worked feverishly to capture the vitality of spring on his canvas. He tried to make the force that empowered growth and fruitfulness visible in his paintings. He eschewed the manner of impressionist painting that merely rendered the effect of sunlight shimmering on the surface of things. In contrast, he layered rich, saturated colors thickly onto his canvases. He almost sculpted the trunks and branches with short energetic strokes of his brush or palette knife. He then dabbed the pastel-colored petals onto the ends of the branches as the crowning glory. Vincent's blossoming trees are triumphant yet at the same time tender images burgeoning with new life.

While still in Nuenen, Vincent had written to Theo that he would "wrestle with nature until she reveals her secret to me."[3] Already then he sensed all that was visible in nature was bound to a greater, invisible creative force. And looking at things for a long time made him realize that the temporal and observable pointed to the eternal and invisible. He wrote to Theo, "It exists! namely the lasting [the eternal] is revealed in that which passes [the temporal]."[4] Vincent painted the essence of what he observed in the orchards in order to reveal that the eternal was revealed in the yearly return of new blossoms. The ordinary subjects of Vincent's paintings can be viewed as symbols for the Something on High. Such paintings of nature—the book through which God spoke—became his statement of faith.

All of Vincent's life experiences that preceded his arrival in Provence had prepared him to express nature's secret through his art: his childhood in the Brabant, when he responded with sensitivity to the natural world; his apprenticeship in the art world, which sharpened his awareness of the expressive power of the visual image; his time of solidarity in the Borinage, where he managed to see beauty in the midst of ugliness; his consoling presence with Sien in The Hague, where he succeeded in making a simple

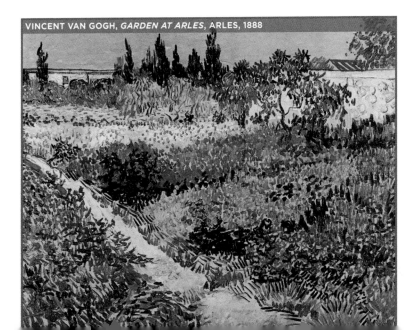

VINCENT VAN GOGH, *GARDEN AT ARLES*, ARLES, 1888

contour line express an emotion; his desire in Nuenen to be an interpreter of peasant life that resulted in the edification of an ordinary meal; his immersion into the world of art in Paris, which deepened his understanding of the mysterious dynamism of colors. Now in Provence, trudging through the wheat fields and blooming orchards, he was able to use the lines of his pen and the colorful strokes of his brush as shorthand to visually express what nature dictated and revealed to him.

The German author Goethe's maxim rang true for Vincent: "He to whom nature begins to reveal her open secrets will feel an irresistible yearning for her most worthy interpreter: Art."[5]

Art had indeed become the language through which Vincent interpreted nature's open secrets. He was deeply moved by what he saw before him and labored tirelessly to make it all intelligible for us on his canvases.

In The Hague, Vincent had aimed at painting not superficial melancholy but images of real struggle and sorrow. Now the bright sun of Provence that intensified the colors made him express pure delight and deep joy; his paintings became true odes to joy, pointing to glimpses of comfort and hope.

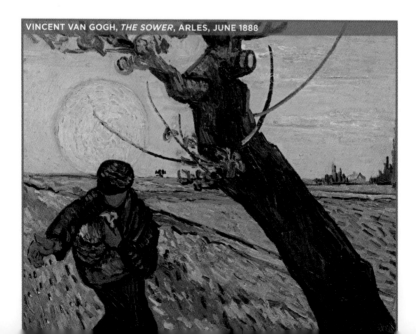

VINCENT VAN GOGH, *THE SOWER*, ARLES, JUNE 1888

The sun: symbol of the divine. Years ago, while he was still practicing his drawing skills, Vincent had written to Theo that wherever he looked he found something worthwhile to sketch, and in the darkest corners of peasants huts he was able to discern rays of light. In Nuenen, that light appeared on his canvases as the warm glow lighting up a cottage window at night or as the faintly flickering lamp hanging above *The Potato Eaters*' table. In the southern climate of Provence, everything was flooded by a much more powerful sun, where even the dark shadows vibrated with colors of cool blues and purples. In Vincent's many landscape paintings of Provence, he painted that sun as golden-yellow orbs flooding the skies with brilliant rays. Its rays enlivened all of life. This was the light that Vincent hoped to bring to all the dark places where people suffered.

For Vincent, the image of the sun was the symbol of the divine, the source that empowers creation. Vincent painted the brilliant suns to express that beyond everyday reality there exists a font of inexhaustible love and light—a light that permeates all the shadows and dark corners of life. The inner beauty, the inner light, the capacity to love inherent in all people came from the same source. Nothing was too insignificant or

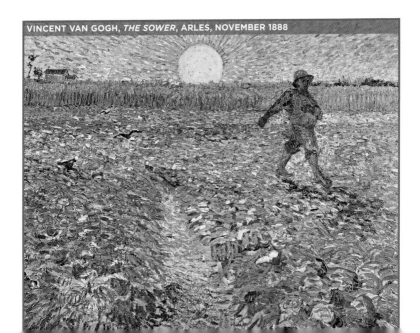

VINCENT VAN GOGH, *THE SOWER*, ARLES, NOVEMBER 1888

too lowly to not have within itself the divine spark of light and love. Writing to his sister Wilhelmine, he relied on a beautiful metaphor to express this belief, that "what the power to germinate is in a grain of wheat, that is love in us."[6]

The all-encompassing rays of a brilliant yellow sun dominate Vincent's painting of *The Sower*, done in June 1888. A sower is scattering his seeds on freshly ploughed soil while at the same time the ripe wheat ready for harvest stands tall in the background. The whole cycle of life, the sorrowful yet always rejoicing of birth, death, and rebirth under the golden orb of the sun offers a vision of comfort.

The end of a dream. In Arles, Vincent had hoped to create a brotherhood of artists who would live and work together as he believed the Japanese artists did. However, his plans were not realized since the only one to respond to his invitation was Paul Gauguin, who only stayed for three months. Gauguin also did not come out of his own conviction but because Theo begged him to join Vincent with a promise to support him monetarily for this commitment.

The relationship between Vincent and Gauguin was stormy and imbalanced from the start and doomed to fail. The two artists did manage to paint together, but they argued over their approach to art as well as about every conceivable detail of their communal life in the yellow house. Yet when Gauguin threatened to leave, it upset Vincent. No one quite knows what conspired between the two men, but Gauguin's decision to part ways with Vincent coincided with the infamous incident of Vincent's injury—the mutilation of one of his ears. Vincent was hospitalized, and Gauguin immediately got on the next train to Paris. This abrupt departure foiled Vincent's hopes of creating a *studio du midi*—his dream of an artists' community. This was very demoralizing for Vincent. His injury also became the portent for the reoccurring seizures and intense headaches that would plague him for the rest of his life.

Vincent was admitted to the hospital a few more times while still in Arles, but he nevertheless continued to paint. One of the paintings

expresses powerfully his consistent attitude of being sorrowful yet at the same time always rejoicing. He painted a remarkable scene of optimism during a difficult time. Dark, snake-like tree trunks are displayed ominously across the canvas in the immediate foreground. They almost form a barrier on which the viewer's gaze is caught. Remaining with the painting a little longer, however, our eyes inevitably are led to the landscape beyond the tree trunks. There one enters a blooming orchard, green and lush and full of promise, comfort, and hope. Just like in his letters in which he often overcame his difficulties by writing encouraging words as much to himself as to Theo, he expresses in this painting his own ongoing efforts to see joy beyond the sorrow, relief beyond the difficulties. Many of his paintings emerged from his own search for respite and endurance.

Vincent's hospitalizations brought his time in Arles to a close. Some citizens of the town construed the episode of Vincent's injury to signify that his behavior was unpredictable and potentially threatening. They petitioned for him to leave Arles. His house was boarded up. Vincent became homeless once again. He had heard of a monastery in Saint-Rémy, not far from Arles, which had, within its walls, created an asylum

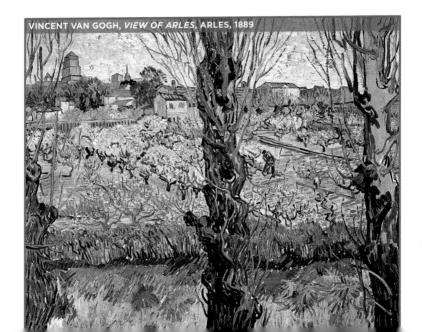
VINCENT VAN GOGH, *VIEW OF ARLES*, ARLES, 1889

for all kinds of people in need of a sanctuary. Vincent sought refuge there and admitted himself in May 1889.

To this day, this beautiful gem of Provence, the Romanesque cloister and historic monastery of Saint-Paul de Mausole, still has an asylum and a psychiatric clinic that offers opportunities to promote the therapeutic value of creating art—the Association Valétudo. Vincent's dream of creating an alliance of artists who would paint and draw together, live in solidarity with each other, and support each other has become a reality.

THE SAFE HAVEN OF A MONASTERY (SAINT-RÉMY)

In this monastery Vincent was given one room as his bedroom, a room to store his paints, and another room to use as a painting studio. These rooms had barred windows. He was fortunate that the doctor in charge understood the vital importance of keeping his patients occupied with meaningful work. He realized that for Vincent painting was the best method to restore his balance and improve his health. Whenever Vincent felt strong enough, he painted. Between his arrival and his departure the following May, Vincent painted more than 140 paintings and did many sketches. Yet he suffered greatly because of his seizures and deteriorating health and also because of the loss of independence and the death of his dream to establish an artist colony. Despite these heavy burdens, he had now entered a time of intense creativity. This was due in part to the result of living in a safe environment where nobody prevented him from painting and where the strictly regulated life of the asylum fostered consistent healthy physical habits. He continued reading and writing his long letters, mostly to Theo. He asked Theo to send him books, preferring at this time to reread the works of Shakespeare. He found companionship with the other patients, sharing once again a deep level of solidarity with human beings in need of compassion and care. He heard their cries and ravings at night and listened to their personal stories during the day. He comforted them, talked with them, and often stayed with them when they were suffering their own seizures.

Sanctuary gardens. Some of Vincent's most extraordinary masterpieces were created during the calm periods between his severe seizures. He spent time walking along the cloister, which opened onto a courtyard—the inner garden. This was the place where monks had strolled in meditative prayer. In this serene setting, surrounded by flowers and blooming bushes, Vincent let nature soothe him. Sitting under the trees in the cool embrace of the walled-in garden made Vincent recall one of Émile Zola's novels. In it a man ill in body and soul is restored back to health by the transformative power of nature in an enclosed paradise-like garden. Vincent strongly identified with this story. He wrote that "nature herself will do me more good than remedies," and it was true.[7]

This sanctuary garden is where his beautiful iris paintings came into being. Crouched among the blooming irises growing there, Vincent studied them face-to-face and drew them from his vantage point of intimacy. He celebrated their distinctive beauty not by rendering them in a realistic manner but by expressing their essence—their iris-ness.

There was another, larger garden within the walls of the monastery grounds that became Vincent's focus for a series of paintings. It was

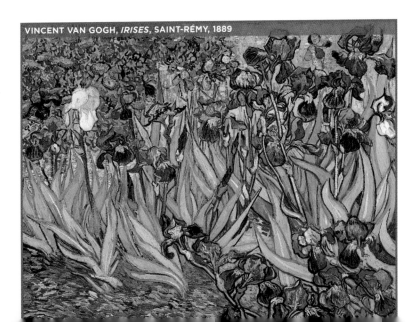

VINCENT VAN GOGH, *IRISES*, SAINT-RÉMY, 1889

an enclosed wheat field that he could see from behind the bars of his windows. Years before, when still in the Borinage, he had compared himself to a bird in a cage, prevented from taking part in life beyond the bars. Now, the real bars did not imprison his creative spirit. They are not visible in the paintings he did of this walled garden. Throughout the one year he spent in the asylum, Vincent observed the changing seasons as the young green wheat matured, ripened, and turned yellow. He watched the sower spreading his seeds in the spring and then the reaper laboring under the radiant glow of the autumn sun to harvest the ripe grain. These sowers and reapers connected him to his lifelong familiarity with the cycles of sowing and reaping and with the laborers of the fields. While painting the figure of the reaper as an image of death, he wrote to Theo,

> I then saw in this reaper—a vague figure struggling like a devil in intense heat to get to the end of his toil—I then saw the image of death, in the sense that humanity would be the wheat being reaped. So it is, if you like, the opposite of that sower I tried doing before. But in this death there is nothing sad, it goes on in full daylight with a sun flooding everything in a light of pure gold. . . .

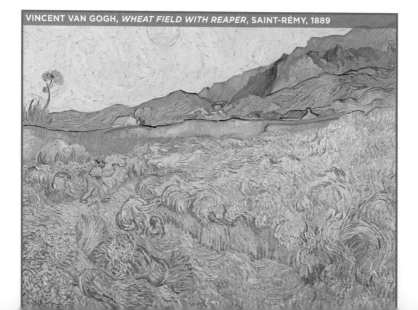

VINCENT VAN GOGH, *WHEAT FIELD WITH REAPER*, SAINT-RÉMY, 1889

It is an image of death as is spoken in the great book of nature—but what I have sought is the "almost smiling."[8]

By painting the reaper in "full daylight," he aimed to make death the complement to life lived on earth, or as he phrased it, the "other side of life." With the "almost smiling," he wanted to offer the comforting vision that death was merely a transitioning into the unseen part of life and that it happened in broad daylight, under the loving embrace of the sun's rays.

Painting his own story. After recovering from seizures and feeling strong enough to paint, Vincent was given an attendant who accompanied him into the countryside surrounding the monastery. His forays beyond the confining walls led him to discover an old marble quarry with large, tumbled boulders and a steep ravine carved deeply through the rock. Both of these places, once fixed on canvas, mirrored his brokenness as well as his intense willpower to resurface from the imprisoning clutch of his sickness.

Humans can be seen struggling to find their way out of the abyss of fallen rocks and gushing water in the paintings *Les Peiroulets Ravine* and *The Quarry at Saint-Rémy*. It is as if Vincent invites the

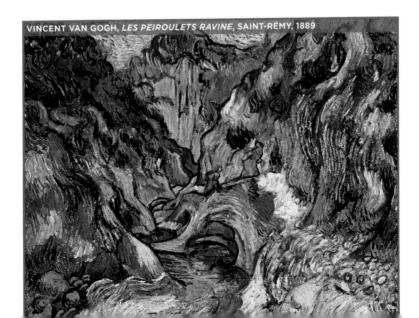

VINCENT VAN GOGH, *LES PEIROULETS RAVINE*, SAINT-RÉMY, 1889

viewer to experience the discomforts of his illness and then to join him in his efforts to emerge from the depths of his pain. And then, as if with a triumphant cry of deliverance, he guides us to the paintings of majestic cypresses, the golden wheat fields, and the mystical olive groves suffused by the brilliant rays of the sun. Even though cypresses are traditionally planted in cemeteries and are associated with dying, Vincent's cypresses, with their flame-like spires, point away from the burdened existence of pain to loftier heights, to glimpses of hope.

Vincent wrote that at times he painted with an amazing lucidity when standing before nature scenes of breathtaking beauty. Time stood still for him then; he was painting as if in a trance. Nature spoke and Vincent responded intuitively. His reverence, his awe, his love for nature was expressed in every piece of art as a loud proclamation of the presence of the divine.

Swirls and spirals. Vincent wrote, "When the sounds cease, God's voice is heard under the stars."[9] The image of Vincent's pulsating night sky has entered into the mainstream of our arts culture in the Western world. All the blues, from light to deep, are colors that by

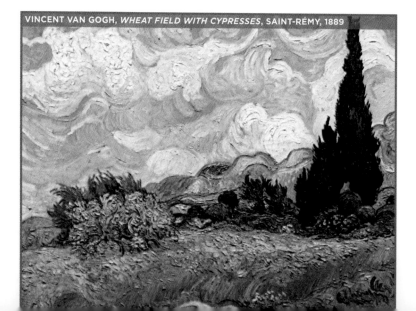

VINCENT VAN GOGH, *WHEAT FIELD WITH CYPRESSES*, SAINT-RÉMY, 1889

their nature recede away from the viewer and thus draw us into the painting where we are caught among the swirling spirals and circles. Ordinarily, the fathomless expanse of the night sky doesn't appear to us the way Vincent painted it—though photographs taken by the Hubble telescope of spiral-shaped galaxies in deep space have a striking resemblance. Thus Vincent's painting leads us to think of those spectacular images. But the silhouette of a dark Dutch village church and surrounding cottages with their lighted windows make the painted scene too earthy to be able to imagine visible galaxies. So we're beckoned to look beyond the obvious to a sign language that surpasses our ordinary, rational way of thinking.

The painting was created while Vincent was feeling homesick for the north and remembering a phrase spoken long ago by a pastor he had heard speak and who he felt had the feelings of an artist in the true sense of the word, for instance, when he said, "Every night the moon came, whispering to me what she had seen in the silent, silent night."[10] Contemplating the deep blue night sky with the sparkling lights of moon and stars over Saint-Rémy may have brought back the sentiments these words had elicited and which had made him write to Theo years before, "The moon is still shining, and the sun and the

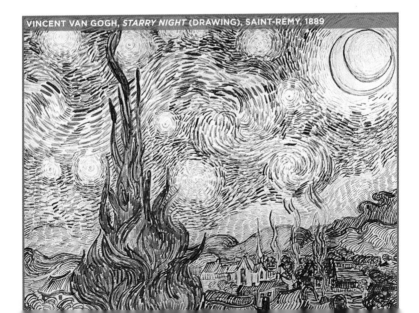

VINCENT VAN GOGH, *STARRY NIGHT* (DRAWING), SAINT-RÉMY, 1889

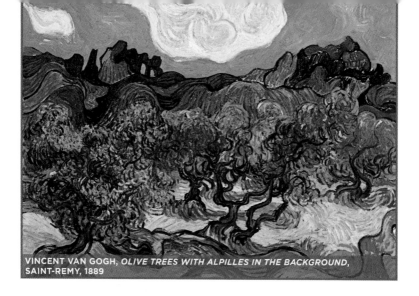

VINCENT VAN GOGH, *OLIVE TREES WITH ALPILLES IN THE BACKGROUND*, SAINT-REMY, 1889

evening star, which is a good thing—and they also often speak of the Love of God, and make one think of the words, Lo, I am with you always, even unto the end of the world."[11]

COPYING REMBRANDT

When Vincent felt extremely tired and not well enough to leave his room, he sometimes reverted to copying black and white prints of works by his favorite artists. This is how some of his most personal and moving paintings emerged. Vincent's copy of Rembrandt's *The Raising of Lazarus* is one such painting. Rembrandt had portrayed the figure of Christ raising his hand in blessing above the grave of Lazarus who is seen in his tomb wrapped in burial bandages. His two sisters, Martha and Mary, are reaching out to him. Vincent replaced the figure of Christ with the bright orb of the sun. Lazarus's two sisters are painted in the semblance of Vincent's friends, Madame Roulin of *La Berceuse* and Madame Ginoux, the *Arlesienne* (a woman of Arles). Both of these women had not only been Vincent's models but had cared for him while he lived in Arles. In the face of Lazarus we see the likeness of Vincent. Thus in this copy Vincent painted his personal experience of feeling vulnerable and ill and of being restored through the compassionate kindness of his friends—who became his modern-day saints and holy women from life. Vincent's interpretations of Rembrandt's *The Raising*

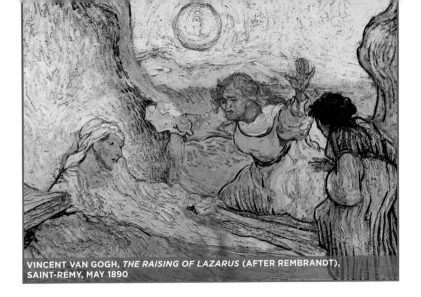

VINCENT VAN GOGH, *THE RAISING OF LAZARUS* (AFTER REMBRANDT),
SAINT-RÉMY, MAY 1890

of Lazarus became a narrative portrait of ordinary people performing ordinary acts, pointing to the relevance of each existing moment and its potential to be compassionate and present one to the other. Vincent gleaned images from religious works done by others, but he rendered only what felt true to his own faith experience.

THE WHEAT FIELDS (AUVERS-SUR-OISE)

Upon the urging of Theo, Vincent left Saint-Rémy after a year and headed north. Theo had married and now had a baby son named Vincent Wilhelm. Theo felt that having his brother closer would enable him to take part in his family life. There was a doctor in Auvers-sur-Oise, a small town north of Paris, who was willing to take Vincent under his care. After a brief visit with Theo, his young wife, Joanna, and his little son, Vincent settled into an attic room at the Ravoux Inn.

During the nineteenth century, Auvers-sur-Oise had been a gathering place for a number of artists. Vincent was aware of this and felt assured this little town with its gardens and its surrounding fields could also inspire him with enough subjects to paint. In fact, in the seventy remaining days of his life, he would fill over seventy canvasses. He had little confidence in the doctor, who himself suffered from melancholy and depression. Yet the two men did become friends. His own health issues aside, Vincent was more concerned about Theo's failing strength.

Theo was not feeling well and at this time had his own worries; he was not happy in his professional life and had the added responsibility of taking care of a young family. And of course Theo continued to support Vincent. The brothers' visits were strained and the weeks in Auvers were difficult. Vincent continued to suffer from his own physical weaknesses and as always felt the lack of a family of his own. But once again, the wheat fields that surrounded Auvers beckoned to him, and he shouldered his canvases and set out to capture them in paint.

The language of pictures. Vincent's images of wheat fields were not merely portrayals of agrarian scenes. He painted the wheat fields because of their major role in the sustenance of life and because of their symbolic representation of eternal rebirth. Once he finished his paintings, he could stand before them and renew the totality of the experience he had had while being surrounded by the real fields. Looking at a wheat field, even just in the form of a painting, he could recall the transformation of the tender greens seedlings into the golden stalks bearing the ripening kernels. Such memories calmed him when he felt discouraged. Writing to his mother, he explained,

> Learning to suffer without complaining, learning to consider pain without repugnance, it is precisely there that one risks vertigo a little; and however, could it be possible, however, could one see even a vague probability that on the other side of life we will perceive good reasons for pain, which seen from down here sometimes takes up the whole horizon so that it achieves the despairing proportions of a deluge. Of that we know very little, of proportions, and it is better to look at a wheat field, even in the form of a painting. [12]

Throughout his efforts at capturing the essence of the scenes surrounding him, Vincent saw how the powerful sun, each blooming fruit tree, sunflower, pollard willow, and star were intertwined into a brilliantly patterned fabric of life. This is how he painted them: woven together, with his brush strokes giving a tangible expression of the

interconnectedness of the whole of creation. This essence of being Paul Tillich, a philosopher and theologian, seemed to capture when he wrote, "All arts create symbols for a level of reality, which cannot be reached in any other way. A picture and a poem reveal elements of reality, which cannot be approached scientifically. In the creative work of art we encounter reality in a dimension which is closed to us without such works."[13] Vincent's art had become nature's most worthy interpreter. He wrote in his last letter to Theo, "Ah well, really, we can only make our pictures speak."[14]

At rest in a wheat field. One of the last scenes Vincent may have gazed at on a hot day in July 1890 was the wavy ocean of ripening yellow wheat that surrounded Auvers. He had left his room at the Ravoux Inn carrying his easel and painting supplies to wander through these fields searching for subjects to paint. But he was injured by a gunshot wound that day. He somehow managed to return to his little attic room in the inn. There he lay down on his narrow bed never to leave it again. Theo was summoned and arrived at Vincent's side within hours. Reminiscent of the days of their boyhood in the parsonage at Zundert, the two brothers shared a pillow for the last two days of Vincent's life. The words they spoke to each other were

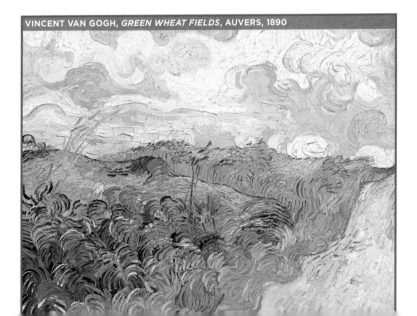

VINCENT VAN GOGH, *GREEN WHEAT FIELDS*, AUVERS, 1890

not recorded in any letters; these remain theirs alone. Vincent died in Theo's arms.

No inquiries were made, no report on what had happened to Vincent surfaced. An article was printed in the local newspaper that a certain artist, a Dutch citizen named Vincent van Gogh, had gone and shot himself in an attempted suicide. Years later new discoveries have pointed to the probable accidental shooting by a group of teenage boys who had made Vincent a butt of their jokes and torment. Vincent did not reveal anything or denounce anyone. It was his last magnanimous act.

Almost thirty years after sitting in Henri's class and being introduced to Vincent, I visited Auvers-sur-Oise. Exiting the little train station where Vincent had arrived over a century ago, I walked north following a path that led beyond the boundaries of the town through the surrounding wheat fields to a walled cemetery. This is where Vincent was laid to rest. And this is where Theo, who died six months after his brother, was eventually brought to join him. I entered the cemetery and stayed a while before their two gravestones side by side against the back wall of the cemetery. True to the metaphors Vincent always saw in nature, he and his brother are united forever by intertwining ivy covering their graves, planted there by Joanna, Theo's wife. Just to the left of their graves, an open archway in the cemetery wall led my gaze to a field of gently swaying golden wheat, ripe for the harvest.

Glimpses of Comfort and Hope

hirty years have passed since the time when the fire trucks came howling out of the night in the dead of winter past our little parsonage on Route 100 in northern Vermont. But I won't forget it.

In a huge city like Los Angeles, the odds are that you don't know the person living two doors down the street, never mind the person who is the object of the paramedics' concern. But in rural America if you see an ambulance heading up a certain road, you begin to speculate right away. Most likely, you know everyone who lives on that road.

The engines came up over the crest of our hill with their shrill sirens rising over the wailing of the north wind. But they couldn't negotiate the steep mountain road that led off the main road into the forest because it was glazed with ice. So the fire could not be put out that cold winter night, and it consumed the home of Danny, his wife, and his two children, one five years old, the other an infant. They were not hurt, but they lost everything. They had become homeless.

We didn't know Danny or his family well. Steve had just begun his ministry in that rural town. We found out that Danny was from "down country" and had moved onto a back road and had begun building a home within the past year. We put out a call for action to the members of our small churches. As soon as the word got out that the fire had taken everything from Danny and his family, one person came forward and offered them temporary housing. Others canvassed for clothing immediately. Everyone responded, particularly our youth fellowship.

We came up with a plan to help the family: we would organize a community talent show to raise money for the family! It was not difficult to find the talent. Steve contacted old-time-fiddler Joe and asked him to dust off his fiddle for the occasion. He asked a sister and brother duo to play their guitars and sing. Then there was old Russ, who promised to play his old pedal steel guitar. He had been in a professional band once and was thrilled to do it because music had been his first love before the bottle had replaced it. We could count on several of our youth group boys for a half dozen quick skits and jokes they had learned in their scout troop. And our all-girls choir was prepared to perform some favorite songs. Steve also wrote a melodrama in which many of the youths from the church fellowship agreed to take part. We had about fifty teenagers involved in the program and as many as twenty-five adults. We made a curtain out of burlap sacks and strung wire from one side of the makeshift stage in the basement of the little schoolhouse—the only place with a large enough seating capacity for this, what promised to be, huge event. On the night of the talent show over two hundred people arrived at the schoolhouse.

The old-time fiddler came forward first and played an old Scottish tune on his fiddle as well as we had ever heard him play. The skits were interspersed throughout all the other numbers. The town folks knew all the actors. They roared at their antics, clapped furiously after each act, and had a marvelous time. Russ was unfortunately too nervous and not in good enough shape to come on and perform with his steel guitar. But the brother and sister duo was charismatic. They played some country music and got everyone singing and clapping. And Steve joined them and performed the Hank Williams number "I Saw the Light" with them and had the audience join in the chorus:

> I saw the light I saw the light
> No more darkness no more night
> Now I'm so happy no sorrow in sight
> Praise the Lord for I saw the light.[1]

Our singing almost lifted the roof off the schoolhouse! With this rousing response of the audience, the trio continued singing "Glory, glory, glory, . . . must have been the hand of my Lord."[2]

Light and glory surrounded us all. Danny and his wife sat in the front row with their children on their laps, their faces aglow with mixed expressions of disbelief and wonder. They had never seen anything quite like this; probably no one there had. And when it came time to pass the hat, the farming families, lumbermen, and miners dug into their pockets and came up with five hundred dollars, a huge sum of money for that community in those years. But it wasn't the money that really made the evening shine. It was the people and their spirit. One week earlier a fire had burned down their neighbor's house. *It could have happened to any of us*, they thought. So they did unto others as they would have wanted it done to them—they poured out their talents and their coins. What happened in that little schoolhouse in a small town in northern Vermont was another act of grace. It was a loving and selfless response to human needs for solidarity and consolation. It exemplified the essence of compassionate living.

MANIFESTING MIRACLES

Years into our ministry in Los Angeles, we received a call that one of our dearest friends in New York had died of blood poisoning. His death could have been avoided had he been able to see a doctor. But he wasn't insured because he was poor and lived alone. Steve was asked by his former congregation to fly back to New York and give the eulogy. Standing before the gathering of his former parishioners, Steve began this difficult task by saying,

> Lyn was my good, good friend. We laughed together and we cried together, but we did not grow old together. Older. But not old. Six months ago, almost to the day, I did something that was highly uncharacteristic. I wrote a personal letter to Lyn, scratched on a piece of paper and sent along to him with a few items in a package.

What I said to him was very personal, perhaps embarrassingly so for him, because I expressed in those lines my deepest gratitude for him being a friend to me, for modeling what it means to be a friend in the truest sense.

And Steve continued eulogizing one of the truest friends he has ever had.

Lyn didn't have any money because he put people before money. He valued friendships more than he valued things. He gave everything he had, wherever he was. Men and women are generally valued by what they acquire. It's one of the big lies, of course, that we are what we own. Lyn measured life and its value by a higher standard. Material wealth came in far, far behind an extensive list of priorities, topped by helping others. That's what he did. He left behind a legacy of people he had helped and nurtured. You never had to ask Lyn to help with anything; he was always one step ahead of the asking. He always offered; he never sat by and expected someone else to do what he could do or to help where he might help. Lyn did not grasp for things. He did not measure his life over and against others. His self-worth was not determined by acquiring or competing or resenting or rivaling. He lived exactly as the apostle Paul stated to the Philippians—that we should live with the mind of Christ. Paul wrote, "Do nothing from selfishness or conceit, but in humility count others better than yourselves" (Philippians 2:3 RSV). This, Paul felt, was a key to life in Christ. And that is what Lyn modeled for us all. Lyn taught us how to trust. He taught us that finding our selfhood in God was all that was necessary. He taught us that you could have your heart broken and still go on loving. He taught us that sacrifice for the ones you love is never too great.

Many parents teach, *If you are not for yourself, then who will be?* The teaching of Lyn was, *If you are only for yourself, what can you possibly hope to become?* Lyn lived the words that Henri wrote—that each one

of us has a special gift, and if we set that gift free, miracles will happen. And they did for all who were blessed by Lyn's life.

SUNFLOWERS

In 2007 Steve had received a grant that allowed him to take a three-month sabbatical. His desire had been to spend as much time as possible with his family. Our three sons were invited to accompany him on a tour to Morocco and to visit several countries in Europe. I too was able to join the four of them the day my summer vacation began. I flew to Paris, took the train, and, just like Vincent 120 years ago, disembarked at the Arles train station. There I reunited with my family and my odyssey began; we followed, albeit backward, in the footsteps of Vincent. For the next four weeks I was able to explore the places where Vincent had lived and painted. While walking through Arles and Saint-Rémy, I had the uncanny sensation of moving in and out of his paintings. Then we traced Vincent backward in time to Paris and further back to the Dutch villages and towns of the Brabant as well as the larger cities of The Hague and Amsterdam. Steve and I also ventured into the dark country of the Belgian mining district, the Borinage.

Everywhere we went, we had serendipitous encounters of proof that Vincent had indeed been there. Some of the Arlesian city scenes like the street café or the bridge over the Rhone still exist. Fields of wheat and olive tree groves seemed unchanged from the paintings he created. Plaques on houses he lived in, a bust of his likeness hidden in the middle of a small, overgrown park in the mining town of Wasmes, a statue of Vincent in the middle of Nuenen or in front of the Zundert church, street names indicating the places he lived, or a print of a self-portrait in the liquor store in The Hague where Vincent had bought the spirits to clean his brushes.

Feeling enriched by the personal contacts with Vincent, I retreated for a while to visit my mother in Switzerland. During this time Steve

traveled to see a dear friend, a pastor in Sweden. While they were together, his friend was called to the home of an elderly man who had recently lost his wife. Steve joined his friend on this pastoral call. They arrived at a low-income senior housing complex and were invited into a small apartment by the widower whose loneliness and grief was accentuated by the very simple and sparse interior. Steve's friend spoke for a while with the widower. Steve shared with me later that beside a few family photographs on the wall hung a small, framed print of Vincent's

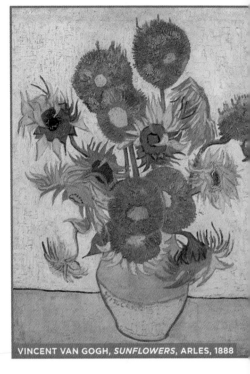

VINCENT VAN GOGH, *SUNFLOWERS*, ARLES, 1888

sunflowers, cut from a calendar. He said, "I immediately understood the significance. This is what Vincent hoped for!" In this simple home, the sunflowers shed a warming radiance, which offered some beauty and comfort.

CONCLUSION

The Essence

Henri had made it clear that we did not need to be art historians or artists ourselves to understand Vincent's art. Our task then and today is to let the painted imagery sink deep into our souls without judging or analyzing. We are to let the painted scenes of his landscapes, close-ups of flowers, portraits of ordinary men and women summon up in our minds the real field, the real sunset, the real olive trees, the real peasants harvesting and sowing, the real mothers rocking their babies. These are all common themes but nonetheless ones that can touch us and attain a deeper meaning, precisely because they have been elevated by being painted onto a canvas.

Vincent's images are coarsely rendered because he did not seek to emphasize the minute details, rather he wanted the image to evoke an emotion and a response. He wished to exalt the experience of everyday moments. It was the essence, distilled from the real things, that needed to speak to us; the quidditas of the field, the tree, the flower, the laborer has to reach us on the level where our soul understands and connects. Our mission then is to make ourselves more receptive to all that we encounter. We are invited to see beyond the obvious and to live more contemplatively, more reverently, and with a greater awareness of the relevance everything around us has in the fabric of our lives. We can think of Vincent's paintings as windows to the sacred. In his book *Bread for the Journey,* Henri, affirming Vincent's view of reality, says, "All that is, is sacred because all that is speaks of God's redeeming love. Seas

and winds, mountains and trees, sun, moon, and stars, and all the animals and people have become sacred windows offering us glimpses of God."[1]

Through letter writing, making and interpreting art, thoughts about faith and compassion in books and imagery, Henri and Vincent each made their voices heard and have become transcendent companions for multitudes of people. Both continue to teach us to look more deeply into the reality of our experiences and see therein the presence of the divine.

OUR COMMON BOND

More than two decades ago, I joined a serpentine line of humanity well before daybreak in front of the Los Angeles County Museum of Art. During the last twenty-four hours of a traveling exhibit of Vincent's works, we were all waiting to gain entrance to see a small selection of his paintings. I had made reservations late and was lucky to receive tickets for a viewing—at two in the morning. The people standing in line with me this night had come not to gawk at oddities that were created by an unbalanced, manic, eccentric artist. They were deeply curious men, women, and youth who had been profoundly touched by something Vincent had expressed in his work. To see so many people standing in line in the middle of the night can be explained in no other way. The anticipation of the crowd was palpable. The wealthy in designer jackets and expensive clothes, the youth in ripped jeans sporting purple hair and piercings, the wrinkled and stooped, the lame and the spry, the fathers and mothers with babies in carriages, the myriad racial mixes representative of the expansive human family—all were in the line. Everyone was aware that the same desire to see Vincent's work united us in a mystical and unique way. And standing there in the midst of this multifaceted slice of humanity, I could see that Vincent had broken down the walls of separation and exclaimed in a universal language that our lives are

interwoven and that we share a common human bond with one another. We have the same needs to be loved and loving, to be understood and to understand, to be comforted and to comfort. Vincent's paintings are above all about these things. Henri hoped we would come to this understanding in the course titled "The Compassion of Vincent van Gogh."

STARRY NIGHT: AN EXPRESSION OF COMPASSION

Years after taking Henri's course at Yale Divinity School, I stood in front of my own classes, introducing my students to artists and to the expressive language of art. Every time I asked the eager young pupils I have taught over the years what they knew about Vincent van Gogh, they raised their hands, waving them excitedly so I would call on them. Invariably they shouted out before I picked one of them to answer my question: "He cut off his ear! He painted the sunflowers! He painted the swirling sky!"

The spirals in *Starry Night* along with the images of the sun, the sower in the wheat field, the flaming cypresses, the sunflowers, and the gnarled olive trees have become Vincent's emblematic vocabulary. In his paintings these aspects of nature gain symbolic meanings pointing beyond the mundane. The curvilinear lines of the spirals, circles of the sun, and silhouetted obelisks of his cypress trees remind me of the ancient signs that accompany the emergence of human life throughout the ages. From simple coiled shapes to tri-spirals to rings surrounded by radiating spokes, such prehistoric symbols have been discovered etched in stone as petroglyphs all over the world. They attest to the desire and need of human beings to communicate and record their intuitive understanding of the underlying energy that permeates all creation and binds it together. Vincent's swirls and spirals—in flower gardens and skies, in the undulating flames of his wheat fields, and in the radiating flames of the petals surrounding the seed heads of his sunflowers—vibrate with this all-pervasive life force.

I tried to teach my students that lines and shapes and colors could actually speak—that vertical lines spoke about solidity, strength, rootedness, whereas horizontal lines expressed rest, and diagonal lines seemed to be in a hurry to leave the page. What about curved lines, jagged lines, or lines that formed shapes? If there was such a thing as a line language, I was curious to see how present-day people would express themselves by using just basic lines. How would we manage to express our thoughts or communicate our feelings without the use of our familiar ABCs?

I led exercises with my students, children and adults alike, inspired by the book *Drawing on the Artist Within* by Betty Edwards. I asked the students to draw, not write, their feelings and emotions based on words like *loneliness*, *joy*, and *anger* on separate small pieces of paper. They could not use familiar symbols but just let their lines and their colors speak intuitively to create their own symbolic language. During workshops on the art and life of Vincent van Gogh, I have often engaged the participants in such experiments. I also added the word *compassion* and asked them to express the meaning of that word through color and line. Once drawn, we displayed these word images side by side to see if we could understand their meanings. What invariably amazed us first was that without copying each other, so many of the expressive line drawings for each respective word were similar. Moreover, the lines and colors were actually readable, that is, they had an interpretive quality.

The *joy* words often showed upward moving lines, spreading out like water gushing skyward from a fountainhead. These lines emulated the joyous expression of upward waving arms swaying in light colors of yellows and oranges. When it came to the expression of *depression* or *loneliness*, generally a single solidly colored circle appeared in one of the lower corners of the paper. Sometimes the circle was boxed in or a line descended diagonally toward the lower corners of the paper. In these drawings the colors were always solemn, dark browns or grays. *Anger* was more often than not expressed in

exploding lines, energetically drawn from the center outward, jaggedly, thickly, and often in reds and blacks.

The many small pieces of paper expressing the word *compassion* were similarly displayed forming a patchwork quilt–like rectangular shape. We gazed on a myriad of curvilinear, spiraling, circular, and concentric lines in blues ranging from deep purples to pastels of pale blue. All those participating in this exercise during my talks about Vincent stood awestruck before a tapestry of word images expressing *compassion*, which emulated the vibrating quality of Vincent's sky. Without analyzing it or seeking expert opinions found in the numerous works written about *Starry Night*, this painting had gained an unexpected revelatory meaning for us.

THE BOOK AT LAST

It has been forty years since I attended Henri's course and twenty years since I received Sue Mosteller's package with Henri's notes. I did not realize that the content of this package would lead me on such an intimate journey with Vincent. Once I reread Henri's handwritten lecture notes, I was compelled to read all of Vincent's nine hundred or so letters. I began stockpiling books about Vincent, about the artists he admired and the authors he read. I read the novels he loved, and, aided

ART STUDENTS' WORK, WORD DRAWINGS, *COMPASSION*

by the commentaries about them in his letters, I gained valuable insights and understood how the protagonists affected him. *La Joie de Vivre* by Émile Zola has become my favorite Zola story, as it was his. And in 2007 I journeyed along Vincent's footsteps through Holland, Belgium, and France. I began giving slide presentations and leading retreats, a far stretch for someone who never liked public speaking. Ten years ago I gave up my art teaching career to focus solely on Vincent. I wrote my first book about him—about his spirituality. I translated the letter quotes therein from Dutch and French into English, meeting Vincent on a more personal level in the expressive and passionate tone of his original words. And now I have come to the conclusion of the book about his compassionate life and about Henri and his desire to share the life of his compassionate saint.

Throughout these years, Vincent has become my guide and my companion too, for almost longer than Henri's relationship with him lasted. I feel as if I have crawled under Vincent's skin and found there in him something truthful, something beautiful, something joyful, and something worth seeing. His creed to love many things has become mine too. And Henri of course has been the catalyst for this movement and call to a more compassionate life. I am so very grateful that both have uplifted, inspired, and gifted me with their life stories and creative work. I sincerely hope that what I have written about Henri and Vincent will touch your lives too.

ACKNOWLEDGMENTS

This book would not have been possible without my husband's initial insistence that I audit Henri's class in 1978. It also would never have been written without Sue Mosteller's "package" sent to me after Henri's death and without Sue's ongoing love, encouragement, patience, and trust in me. I am indebted to her and so very grateful. As the manuscript evolved over the years, it has become so clear that it could also not have been written without the countless encounters throughout our ministry with the people in our parishes and communities who have caringly reached out to us. Our time in the two northern Vermont parishes provided for us the most fertile ground from which our ministry would continue to grow. My deepest gratitude is extended to all those folks in the Green Mountains who nurtured us during our first three years in ministry together. Greatest appreciation goes to my family and especially to Steve for his enduring encouragement and advice throughout the years and for accepting that Vincent van Gogh was the "other man" in our marriage. Being a student and teaching assistant of Henri's, Steve could value the passion that I felt for Henri's saint and often joined me in my research. My whole family shared my enthusiasm as I prepared the manuscripts and many workshops, retreats, and lectures. And finally, my gratitude goes to Vincent and Henri for leaving us with their bountiful, profoundly personal reflections and lasting legacy on the call to live a compassionate life.

NOTES

INTRODUCTION: ENCOUNTERING HENRI AND VINCENT

[1] Henri Nouwen, introduction to "The Compassion of Vincent van Gogh" (lecture, Yale University, New Haven, CT, 1978), audiotape.

[2] Maurice Beaubourg, *Exhibition Catalogue Number 134*, Stedelijk Museum Amsterdam, summer 1955, 1.

[3] Dr. Vincent van Gogh, in Nouwen, "Compassion of Vincent van Gogh."

[4] Nouwen, "Compassion of Vincent van Gogh."

[5] Henri J. M. Nouwen, "Compassion: Solidarity, Consolation and Comfort," *America*, March 13, 1976.

1: HENRI

[1] Vincent van Gogh, letter to Theo van Gogh, Cuesmes, between June 22 and 24, 1880. Hereafter Vincent's name will not be included in the notes regarding his letters; only Theo's first name will be used. The city Vincent was writing from follows the recipient's name.

[2] Henri J. M. Nouwen, "Compassion: Solidarity, Consolation and Comfort," *America*, March 13, 1976.

[3] Letter to Theo, The Hague, October 22, 1882.

[4] Nouwen, "Compassion."

[5] Henri J. M. Nouwen, "Solidarity in Weakness: February 1," *Bread for the Journey* (San Francisco: HarperSanFrancisco, 1997).

[6] Nouwen, "Compassion."

2: VINCENT

[1] Letter to Theo, The Hague, November 16 or 17, 1882.

[2] Letter to Theo, Nieuw-Amsterdam, October 28, 1883.

[3] Mark Edo Tralbaut, *Vincent van Gogh* (New York: Viking Press, 1969), 28.

[4] Letter to Theo, The Hague, between December 4 and 9, 1882.

[5] Letter to Theo, The Hague, November 24, 1882.

[6] Letter to Theo, Etten, on or about December 23, 1881.

[7] Letter to Theo, Paris, on or about Thursday, September 9, 1875.

[8]Letter to Theo, Isleworth, October 3, 1876.

[9]Letter to Theo, Saint-Rémy, May 9, 1889.

[10]Letter to Theo, Arles, September 18, 1888.

[11]Letter to Theo, Amsterdam, April 3, 1878.

[12]Letter to Theo, Isleworth, October 13, 1876.

[13]Letter to Theo, Laeken, on or about November 13 and 15 or 16, 1878.

[14]Georges Duez, *Vincent van Gogh au Borinage* (Mons, Belguim: Federation du Tourisme de la Province de Hainaut, 1976).

[15]Tralbaut, *Vincent van Gogh.*

[16]Tralbaut, *Vincent van Gogh.*

[17]Tralbaut, *Vincent van Gogh.*

[18]Tralbaut, *Vincent van Gogh.*

[19]Letter to Theo, Wasmes, between March 4 and 31, 1879.

[20]Letter to Theo, Laeken, on or about November 13 and 15 or 16, 1878.

[21]Letter to Theo, Cuesmes, August 5, 1879.

[22]Letter to Theo, Laeken, on or about November 13 and 15 or 16, 1878.

[23]Letter to Theo, Cuesmes, August 5, 1879.

[24]Letter to Theo, Cuesmes, between June 22 and 24, 1880.

[25]Letter to Theo, Cuesmes. between June 22 and 24, 1880.

[26]Letter to Theo, Nuenen, on or about October 10, 1885.

[27]Letter to Theo, Cuesmes, September 24, 1880.

[28]Letter to Theo, Cuesmes, September 24, 1880.

3: MY STORY

[1]Letter to Theo, Wasmes, between April 1 and 16, 1879.

4: HENRI

[1]Henri J. M. Nouwen, "Compassion: Solidarity, Consolation and Comfort," *America*, March 13, 1976.

[2]Nouwen, "Compassion."

[3]Nouwen, "Compassion."

[4]Henri Nouwen, "The Compassion of Vincent van Gogh" (lecture, Yale University, New Haven, CT, 1978), audiotape.

[5]Nouwen, "The Compassion of Vincent van Gogh."

[6]Letter to Theo, Cuesmes, between August 11 and 14, 1879.

[7]Letter to Theo, The Hague, May 12 or 13, 1882.

[8]Nouwen, "Compassion."

[9]Letter to Theo, The Hague, on or about May 10, 1883.

5: VINCENT

[1]Letter to Theo, Cuesmes, between June 22 and 24, 1880.
[2]Letter to Theo, Etten, November 18, 1881.
[3]Letter to Theo, Cuesmes, between June 22 and 24, 1880.
[4]Letter to Theo, Cuesmes, between June 22 and 24, 1880.
[5]Letter to Theo The Hague, January 3, 1883.
[6]Letter to Theo, The Hague, May 12 or 13, 1882.
[7]Letter to Theo, Etten, mid-September 1881.
[8]Letter to Theo, Cuesmes, September 7, 1880.
[9]Letter to Theo, The Hague, on or about May 7, 1882.
[10]Letter to Theo, The Hague, December 10, 1882.
[11]Letter to Theo, The Hague, December 10, 1882.
[12]Letter to Theo, Nuenen, on or about December 26, 1883.
[13]Letter to Theo, The Hague, on or about July 21, 1882.
[14]Letter to Theo, Nuenen, April 6, 1885.
[15]Letter to Theo, The Hague, August 26, 1882.
[16]Letter to Theo, Nuenen, April 30, 1885.
[17]Letter to Theo, Nuenen, July 14, 1885.
[18]Letter to Theo, Nuenen, May 22, 1885.
[19]Letter to Theo, Nuenen, April 30, 1885.
[20]Letter to Theo, Nuenen, on or about July 14, 1885.
[21]Letter to Theo, Nuenen, on or about July 14, 1885.
[22]Letter to Theo, Nuenen, May 4 and 5, 1885.

6: MY STORY

[1]Henri Nouwen, *Out of Solitude: Three Meditations on the Christian Life* (Notre Dame, IN: Ave Maria Press, 1974).

7: HENRI

[1]Eugene Delacroix, "Eugene Delacroix," *New World Encyclopedia*, accessed July 23, 2018, www.newworldencyclopedia.org/entry/Eugene_Delacroix.
[2]Henri Nouwen, "The Compassion of Vincent van Gogh" (lecture, Yale University, New Haven, CT, 1978), audiotape.
[3]Letter to Theo, Arles, October 1888.
[4]Henri J. M. Nouwen, "Compassion: Solidarity, Consolation and Comfort," *America*, March 13, 1976.

[5]Nouwen, "Compassion."

[6]Verbatim dialogue from Henri's taped lecture at Yale Divinity School, referring to Vincent's letter to Theo from The Hague, November 1882.

[7]Nouwen, "Compassion."

8: VINCENT

[1]Eugene Delacroix, quoted in Hubert Wellington, *The Journal of Eugene Delacroix* (London: Phaidon Press, 1995).

[2]Letter to Theo, The Hague, July 31, 1882.

[3]Letter to Theo, Nuenen, on or about January 26, 1885.

[4]Letter to Theo, Nuenen, on or about January 26, 1885.

[5]Johann Wolfgang von Goethe, in *The Maxims and Reflections of Goethe*, trans. Thomas Bailey Saunders (Whitefish, MT: Kessinger, 2009).

[6]Letter to Wilhelmine, Paris, late October 1887.

[7]Letter to Theo, Arles, on or about April 24, 1889.

[8]Letter to Theo, Saint-Rémy, September 5 and 6, 1889.

[9]Letter to Theo, Amsterdam, September 18, 1877.

[10]Letter to Theo, Amsterdam, July 9, 1877.

[11]Letter to Theo, Amsterdam, July 9, 1877.

[12]Letter to Anna Carbentus van Gogh, Saint-Rémy, July 2, 1889.

[13]Paul Tillich, *Dynamics of Faith* (New York: Harper & Row, 1957).

[14]Letter to Theo, Auvers-sur-Oise, July 23, 1890.

9: MY STORY

[1]Hank Williams, "I Saw the Light," *I Saw the Light* (single), MGM, 1948.

[2]Regina Stark, "Must Have Been the Hand of the Lord," 1957.

CONCLUSION: THE ESSENCE

[1]Henri J. M. Nouwen, "The Created Order of Sacrament: September 22" in *Bread for the Journey* (San Francisco: Harper San Francisco, 1997).

IMAGE CREDITS

formatio
TRADITION. EXPERIENCE.
TRANSFORMATION.

Formatio books from InterVarsity Press follow the rich tradition of the church in the journey of spiritual formation. These books are not merely about being informed, but about being transformed by Christ and conformed to his image. Formatio stands in InterVarsity Press's evangelical publishing tradition by integrating God's Word with spiritual practice and by prompting readers to move from inward change to outward witness. InterVarsity Press uses the chambered nautilus for Formatio, a symbol of spiritual formation because of its continual spiral journey outward as it moves from its center. We believe that each of us is made with a deep desire to be in God's presence. Formatio books help us to fulfill our deepest desires and to become our true selves in light of God's grace.